A Little Feminist
History of Art

T0266841

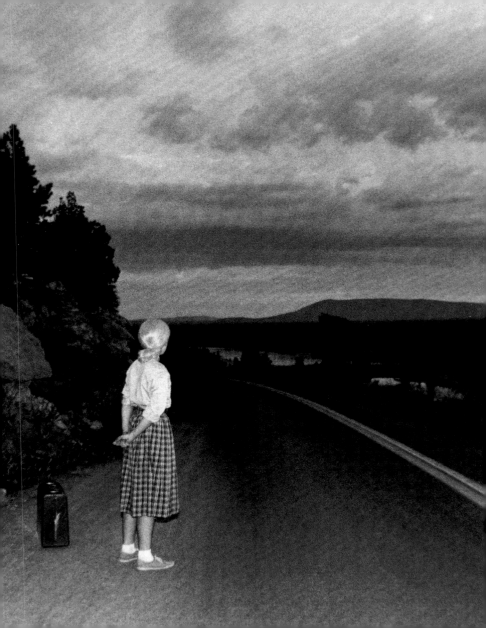

A Little Feminist
History of Art

Charlotte Mullins

First published 2019 by order of the Tate Trustees
by Tate Publishing, a division of Tate Enterprises Ltd,
Millbank, London SW1P 4RG
www.tate.org.uk/publishing

Reprinted 2021, 2024

A catalogue record for this book is available from the
British Library

ISBN 978-1-84976-656-2

Distributed in the United States and Canada by ABRAMS,
New York

Library of Congress Control Number: applied for

Project Editor: Emma Poulter
Production: Roanne Marner
Picture Researcher: Emma O'Neill
Design: Sarah Krebietke
Colour reproduction by DL Imaging, London
Printed and bound in China by C&C Offset Printing Co., Ltd

MIX
Paper | Supporting
responsible forestry
FSC® C008047

Measurements of artworks are given in centimetres,
height before width

front cover: Linder *Untitled* 1976. See pp.48–9
back cover: Sarah Lucas *Self-Portrait with Fried Eggs*
1996 (detail). See pp.96–7
page 2: Cindy Sherman *Untitled Film Still #48* 1979
(reprinted 1988) (detail). See pp.60–1

Contents

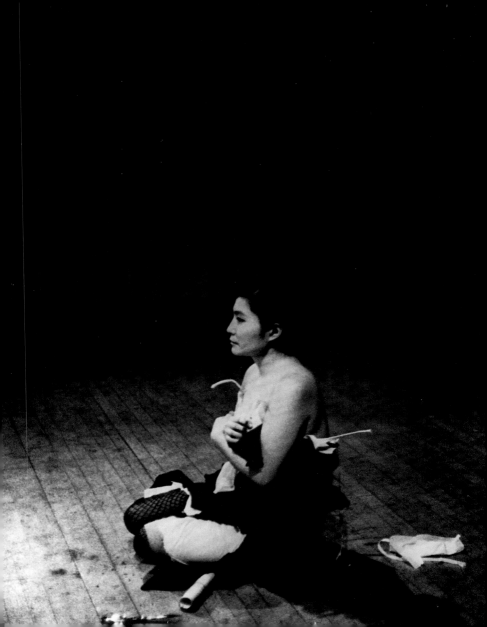

THIS IS A MAN'S WORLD …

What does it mean to be a feminist in the twenty-first century?
The award-winning novelist Chimamanda Ngozi Adichie explores
this in her recent polemic *We Should All Be Feminists*. People
would ask her: 'Why the word feminist? Why not just say you are
a believer in human rights, or something like that?' She felt that
would be dishonest. 'For centuries, the world divided human beings
into two groups and then proceeded to exclude and oppress
one group. It is only fair that the solution to the problem should
acknowledge that,' she says.[1] Sonia Boyce, an influential advocate
for Black women in Britain, concurs: 'I genuinely don't understand
why everyone isn't a feminist – it's simply about being treated fairly.
It's the same with race: what is so difficult about all people being
treated equally?'[2]

According to academic Lisa Tickner the women's movement, as
feminism was originally called in the 1960s, boiled down to two things:
finding a distinct voice for women (separate to the patriarchal or
dominant male voice) and reclaiming the representation of women.[3]
Author and activist bell hooks (who chooses not to capitalise her
name so as to focus attention on her work, not her personality)
defines feminism as a 'movement to end sexism, sexist exploitation
and oppression', while critic Lucy R. Lippard believed it was 'neither
a style nor a movement', but rather 'a value system, a revolutionary
strategy, a way of life'.[4]

Feminism is an ongoing belief in the right of women to be heard
and the right to equality. So how then do we define feminist art? There
is no dominant medium – although new media, unsullied by male

dominance, feature heavily and traditional painting and sculpture are all but abandoned – and there is no prescribed style. Feminist art crosses borders and generations, and is found on billboards and in shopping centres as well as in museums and galleries. Much feminist art addresses the perceived bias of a world created for and dominated by men, what Grayson Perry disparagingly refers to as 'a Default Male World' in his 2016 book *The Descent of Man*.[5] Feminist art questions the construction of femininity, the idea that women are not born but made, as presciently identified by Simone de Beauvoir in *The Second Sex* in 1949. Early feminist artists reclaimed the body as subject not object while also tackling the invisibility of women and women's work, despite a lack of funding or support from male-run institutions. They drew attention to the silencing – both physical and psychological – of generations of women, something Mary Beard describes as 'deeply embedded in Western culture' and Rebecca Solnit refers to as 'the slippery slope of silencings'.[6] Feminist artists also presented new ways of working: non-linear, collaborative, supportive of multiple and contradictory approaches.

This book highlights the work of fifty artists from 1968 to the present day who confront, explore, expand and probe the issues of feminism. As women around the world have taken up the cause the chorus of voices – shaped by race, class, age, sexuality and geopolitics – has led to the more expansive term 'global feminisms'. Where possible I have included each artist's voice to retain a sense of this diversity. I hold with the idea that feminism is ongoing, a permanent state of 'becoming', and so have opted to exclude any divisions into second wave, third wave and fourth wave feminism and rather celebrate feminist art for its complex, radical, collaborative, messy, inspiring and vital past, present and future.

BODY POLITICS

The origins of the women's movement could be seen to predate the Victorian era but it is with the rallying cries of the first suffragettes that it gathered real force. Emmeline Pankhurst, Emily Davison and many others braved arrest, prison and death to campaign for the vote for women in Britain, while suffragists such as Millicent Fawcett negotiated their way towards the same goal. Two World Wars later, with women contributing significantly to the workforce and equal voting rights in place in Britain, America and much of Europe, conditions for women had improved. And yet as the 1960s ebbed dissent began to rise again.

Artists such as Yayoi Kusama and Yoko Ono, both living in New York, were trailblazers of feminist art. They took back control of the female body – most noticeably their own – in performances held in Kyoto, New York and London in the 1960s. Yet without words to frame, document and celebrate women's art much of it went unnoticed by history, absent from art magazines and newspapers, rarely featured in glossy monographs or survey show catalogues (or the exhibitions they supported). Women would have to get things moving for themselves.

Building on the success of the civil rights movement and the widespread student protests of 1968, women artists realised they could amplify their voice by collaborating with each other. Early feminist groups began to coalesce in America, such as New York Radical Women (1967–9). *Ms*. magazine was launched and the Feminist Art Program at CalArts, Los Angeles enrolled its first students in 1971. The impact of these cooperatives and courses was powerful. Judy Chicago (p.38), who co-led the Feminist Art

Program, said: 'The program kind of exploded. It was … like taking the lid off a boiling pot of water.'[7] In the UK Germaine Greer published *The Female Eunuch* (1970), *Spare Rib* magazine was founded and the Women's Workshop of the Artists' Union was initiated (both in 1972).

On either side of the Atlantic the new feminist cooperatives were non-hierarchical and collaborative in nature, designed to offer mutual support and strength in numbers. They organised their own exhibitions, staged demonstrations and performances and published articles on each other's work. Many of them turned to photography to create or document their art, often for the same reason as Laurie Simmons (p.56): 'When I picked up a camera with a group of other women, I'm not going to say it was a radical act, but we were certainly doing it in some sort of defiance of, or reaction to, a male-dominated world of painting.'[8]

In the 1970s John Berger and Laura Mulvey exposed the coded systems at play that objectified women in art, in advertising and on screen. Art historians Linda Nochlin, Griselda Pollock and Rozsika Parker illuminated the dearth of research on women artists. In their influential *Old Mistresses: Women, Art and Ideology* (1981), Parker and Pollock argued that history was prejudiced, designed to exclude women artists and promote men: 'To discover the history of women and art is in part to account for the way art history is written. To expose its underlying values, its assumptions, its silences and its prejudices is also to understand that the way women artists are recorded and described is crucial to the definition of art and the artist in our society.'[9]

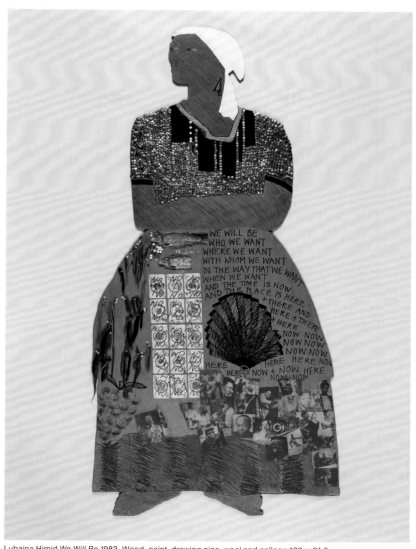

Lubaina Himid *We Will Be* 1983. Wood, paint, drawing pins, wool and collage 183 × 91.5

GREAT WOMEN ARTISTS

The Guerrilla Girls, who tagged their work 'the conscience of the art world', came together because they felt that 'active' feminism was dying out. Feminism as a whole was certainly getting bad press (when it received any at all), increasingly seen as outdated and irrelevant. Many artists wanted their work to be seen first and foremost as art, not as art made by a woman. Academics started to talk of post-feminism, of a society beyond gender boundaries and roles. As the 1990s dawned, many of the artists later dubbed Young British Artists (YBAs) graduated from Goldsmiths in London. It was a time of Britpop and bravado, lager and ladettes; a time when artists drank until dawn at the Groucho Club and Charles Saatchi bought everything they made. Sarah Lucas (p.96), Tracey Emin, Cathy de Monchaux, Rachel Whiteread, Gillian Wearing – all achieved huge success in the 1990s (and all could have been included in this book had space allowed). But was there an underlying problem here? In 1971, in her essay 'Why Have There Been No Great Women Artists?', Linda Nochlin identified the only way for women artists to get ahead in a man's world: 'It is only by adopting, however covertly, the "masculine" attributes of singlemindedness, concentration, tenaciousness and absorption in ideas and craftsmanship for their own sake, that women have succeeded.'[14] Could women artists still only succeed if they aped male behaviour? What happened when they had children or had to work part-time? De Monchaux became a mother shortly after being shortlisted for the 1998 Turner Prize. It seems women artists often have to make difficult choices and adjust their priorities when they become parents (in a way that male artists don't) and their careers can suffer as a consequence.

Sarah Lucas *Eating a Banana* 1990. Digital print on paper 53.9 × 59.6

Cathy de Monchaux *Never Forget the Power of Tears* 1997. Steel, lead, leather, fabric, fibreboard and plastic 689 × 421.5

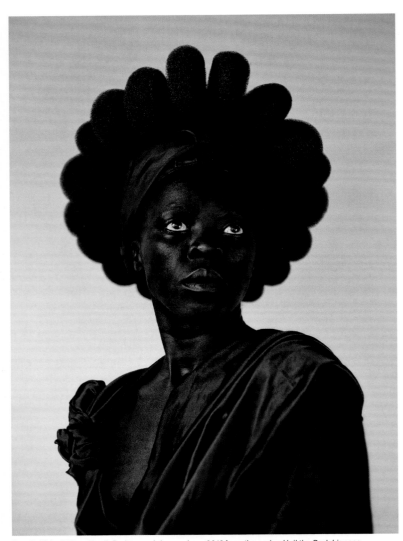

Zanele Muholi *Ntozakhe II, Parktown, Johannesburg 2016* from the series *Hail the Dark Lioness*.
Gelatin silver print 100 × 72

FEMINISM GOES GLOBAL

As Britain focussed on the YBAs, feminism was rapidly being taken up by artists across the globe: by Chinese and Iranian artists, Argentinians and South Koreans, artists from Kenya, Malawi and South Africa. What did feminism mean to these artists? The story of Shirin Neshat (p.90) offers one example. Neshat had grown up in Iran but left to study in California as political tensions rose. The Iranian Revolution of 1979 saw Mohammad Reza Pahlavi overthrown and a conservative religious government installed in his stead. Abrupt changes were imposed including the law that all women in public must now wear the veil. Neshat didn't return home for seventeen years and when she did, the country she remembered was gone. A talk she gave at the TEDWomen conference in Washington, DC, in December 2010, began: 'The story I want to share with you today is my challenge as an Iranian artist, as an Iranian woman artist, as an Iranian woman artist living in exile.' Working in exile in America, Neshat is critical of the West's perception of Middle Eastern women as well as the 'atrocious' Iranian government 'who have done every crime in order to stay in power'.[15] Art gives her a voice and through it she speaks for all Iranian women. She said of her fellow Iranian artists in exile: 'We are the reporters of our people and are communicators to the outside world. Art is our weapon. Culture is a form of resistance.'[16]

Feminism has been informed and shaped by race and class and sexuality; by artists from different economic and aesthetic backgrounds; by politics and circumstance. It has been weaponised and problematised and put to work. Some artists have given voice to a country and others have had to work in isolation. Some have used feminism to highlight extreme patriarchal customs – including

rape, exploitation and murder – that continue to this day. Zanele Muholi (pp.16, 102) for example, documented hate crimes against the Black lesbian community in South Africa between 2002 and 2006 – cases where lesbian women were raped by men who claimed to believe it would 'cure' them. 'The rape act,' Muholi says, 'is a weapon meant to put black lesbian women in "their place" in our society.'[17]

THE FEMINAISSANCE

In this book I have tried to represent as wide an interpretation of feminism as possible, and to include artists whose work expands our understanding of what feminism can be. In spite of the struggle, it is heartening that, over the last fifteen years, these artists have received far greater exposure than ever before. Museums and galleries have implemented programmes to ensure more work by women is displayed, with some (such as Tate) even aiming for parity. In 2007 there were so many major exhibitions of feminist art across Europe and America that critics hailed it 'the feminaissance'.[18] More recently exhibitions such as the seminal 1972 show *Womanhouse*, the first public exhibition of feminist art, have been remade and key early feminists, including Joan Jonas (p.28) and Alexis Hunter (p.54), have had major retrospectives.[19]

With the age of social media, feminism has returned to mainstream culture. In 2017 women across the arts shared stories about sexism, abuse and misuses of power. The hashtag #MeToo, in circulation since 2006, went viral on Twitter in response to allegations made against former film producer Harvey Weinstein. In 2013 the hashtag #BlackLivesMatter mobilised people worldwide to campaign against systemic racism and (less visibly) institutional prejudices faced by Black women.[20] These hashtags are non-hierarchical and

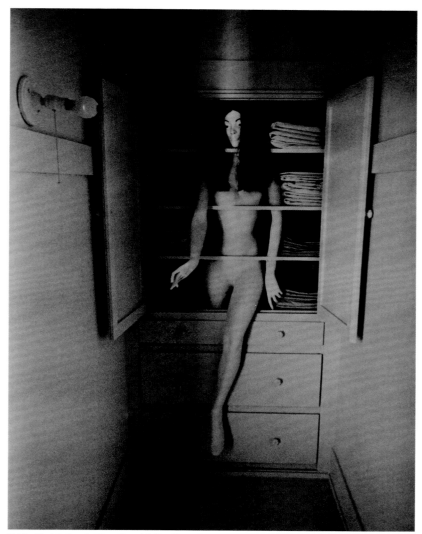

Original installation shot from the exhibition *Womanhouse* 1972, Los Angeles, showing *Linen Closet* by Sandy Orgel

MONICA SJÖÖ
(1938 – 2005)

In 1970 Monica Sjöö was invited to show six works in the south-west arts festival in Cornwall. She installed *God Giving Birth* at the Guildhall in St Ives but within minutes local councillors and police appeared and took the work down. The problem? God was a woman. And she was giving birth.

Sjöö's god straddles a dark Earth with a baby appearing between her legs, a celebration of God's omnipotence. 'If I had called her "Goddess",' Sjöö reflects, 'then She could have been passed off as one of many Goddesses and/or a fertility image, not as the cosmic creative power I intended to express.'[26]

When the painting was exhibited three years later as part of *Five Women Artists: Images on Womanpower* at the Swiss Cottage Library in London, Scotland Yard investigated whether it was pornographic. The ensuing press coverage drew the crowds and comments in the visitors' book highlight the painting's impact: 'This show has given me courage. I no longer feel I have to apologize for doing women's painting; now I can go right ahead.'[27]

God Giving Birth 1968
Oil paint on hardboard
185 × 122

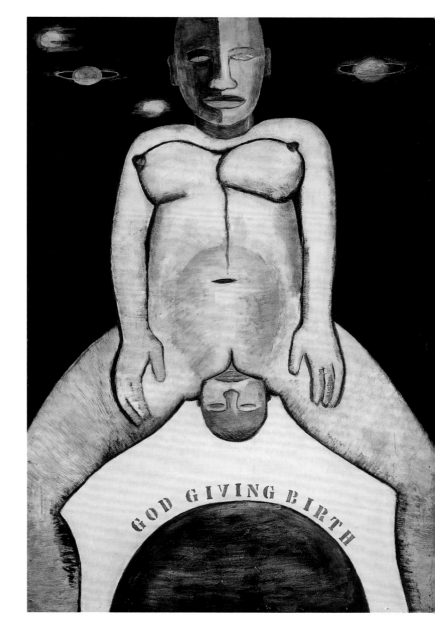

VALIE EXPORT
(b.1940)

In an arthouse cinema in Munich in 1968, VALIE EXPORT staged one of her best-known actions, *Genital Panic*. The audience were there to watch short films by experimental film-makers. EXPORT had been invited to participate but instead of submitting a film she appeared in person, barefoot and with backcombed hair, dressed in a bomber jacket and crotchless trousers. With her genitals at face level she stalked through the audience, holding a gun. Her message was clear – male directors objectified women on the screen and she was reclaiming the female body. The gun she toted was both a phallic stand-in for the director's ego and a physical threat to connect the audience directly to the action.

EXPORT argued for the acceptance of a new movement: 'Feminist Actionism seeks to transform the object of male natural history, the material "woman", subjugated and enslaved by the male creator, into an independent actor and creator, subject of her own history.'[28] As such she wanted her art to be experienced on the streets, not in art galleries. In 1969 Peter Hassmann photographed EXPORT in the outfit she wore for *Genital Panic*; the image was screenprinted and flyposted across Vienna and later Berlin.

Action Pants: Genital Panic 1969
Six screenprints on paper
66 × 46 (each)

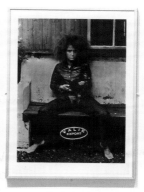
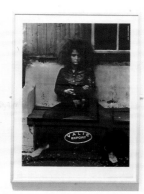
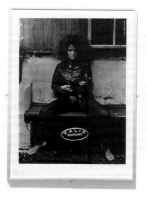
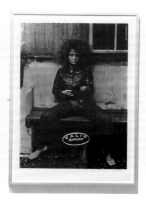
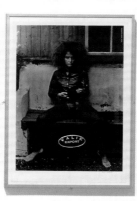

ELEANOR ANTIN
(b.1935)

Carving: A Traditional Sculpture was made by Eleanor Antin for the Whitney Annual in New York in 1972. Antin decided to submit her own version of an academic sculpture so she went on a crash diet. Every day bar one, from 15 July to 21 August, she photographed her naked body from the back, front and both sides as her weight slowly reduced (she lost nine pounds in total). 148 gelatin silver prints comprise the work, displayed in columns of four and stretching in date order along the wall.

In the 1970s women artists often worked with their own (naked) bodies to reclaim them from the gaze of the male viewer and turn object back into subject. For Antin, her body was her art, and by dieting she was 'carving' her body from within. She related the experience to that of a classical sculptor: 'This piece was done in the method of the Greek sculptors,' she says, 'carving around the figure and whole layers would come off at a time until finally the aesthetic ideal had been reached.'[29] She saw the final work as being determined by her intention and the limits of her material: her own body.

Carving: A Traditional Sculpture (detail) 1972
148 photographs; gelatin silver prints and text
17.8 × 12.7 (each)

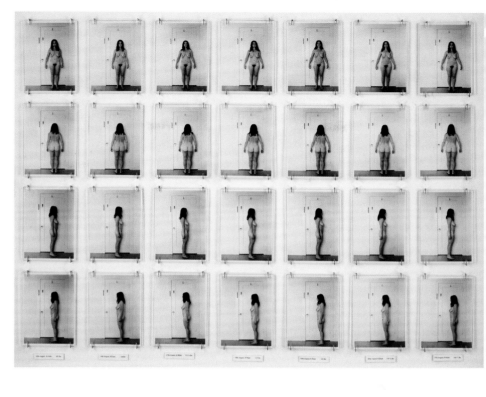

JOAN JONAS
(b. 1936)

In *Organic Honey's Visual Telepathy,* an atmospheric black-and-white film, Joan Jonas and her alter ego Organic Honey perform for the camera. Their bodies are fragmented and duplicated by mirrors and – as her alter ego – Jonas's body is adorned and disguised by props, including costume jewellery and an ornate feather headdress. The film was made by Jonas using video camera footage of her performance. '*Organic Honey's Visual Telepathy* … was based on a poetic approach to expressing my relationship to feminism,' Jonas says. 'It involved a search for whether or not there could be something such as female art, female imagery.'[30]

Jonas was an early advocate of video, enjoying the lack of male dominance in the new medium (unlike traditional art forms such as painting and sculpture). She bought her first camera in 1970 and enjoyed being able to work in her loft in 'a closed–circuit situation' – privately and without the need for paid assistants or crew.[31]

Jonas's 2018 retrospective at Tate Modern in London showed her continuing interest in themes explored in *Organic Honey's Visual Telepathy* – her use of masks and mirrors to fragment and distort gender and expectation, and the blending of static motifs with movement.

Organic Honey's Visual Telepathy 1972
Multimedia recording; single-channel video, black and white, sound
17 minutes 24 seconds

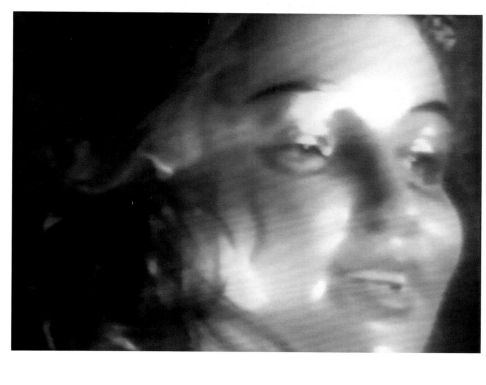

MIRIAM SCHAPIRO
(1923–2015)

In 1972 a group of twenty-eight artists installed their work in a dilapidated mansion in Hollywood. The artists – all women – created *Womanhouse*, one of the most significant exhibitions in feminist art history. On the first day only women could enter; in total 10,000 people visited.

The exhibition had its roots in an early Feminist Art Program run by Miriam Schapiro, Judy Chicago and Paula Harper at CalArts (California Institute of the Arts) in Los Angeles. 'There are some interesting unwritten laws about what is considered appropriate subject matter for art making,' Schapiro says. 'The content of our first class project "Womanhouse" reversed these laws. What formerly was considered trivial was heightened to the level of serious art-making: dolls, pillows, cosmetics, sanitary napkins, silk stockings, underwear, children's toys, washbasins, toasters, frying pans, refrigerator door handles, shower caps, quilts and satin bedspreads.'[32]

Schapiro created a dolls' house in collaboration with Sherry Brody for *Womanhouse*. It had a variety of contrasting rooms to allude to the complexity of being a woman: mother, lover, nanny, cleaner, artist. The front folded back to expose the complicated private–public role of domestic life, at once hidden from view (and from history), but at the same time a place of encoded traditions and expectations.

Dollhouse 1972
Wood and mixed media
208.3 × 202.6

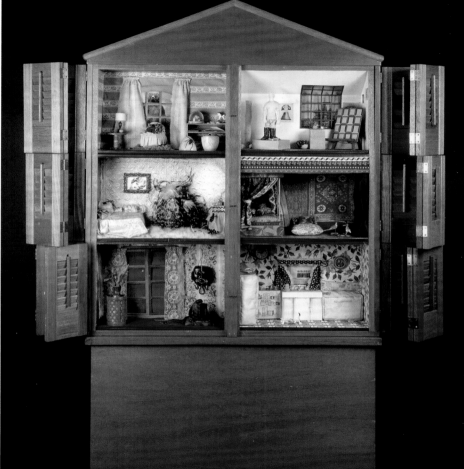

ANA MENDIETA
(1948–85)

Many women artists used their body as subject matter in the 1970s but few used it with such emotive impact as Ana Mendieta. While studying for her second Masters degree at Iowa University she reacted to the rape and murder of a fellow student by staging a recreation of the crime scene. In her apartment she smashed crockery and stage-lit the living room. When people arrived to see her performance they found her tied to a table, naked from the waist down and covered in blood. She later remembered that the audience 'all sat down and started talking about it. I didn't move. I stayed in position about an hour. It really jolted them'.[33]

Mendieta was influenced by Fluxus and the Viennese Actionists. Like the Viennese Actionists she was drawn to using blood and rituals as a method of communicating directly with the emotional core of each viewer. By physically recreating the rape and murder she powerfully communicated the brutality of the attack. This work, now existing as a series of unique photographs, still has the power to connect directly to the viewer's emotions with terrifying clarity.

Untitled (Rape Scene) 1973
Colour photograph
25.4 × 20.3

32

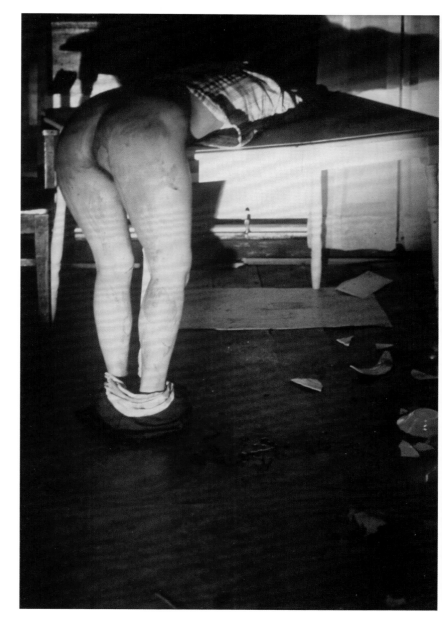

MARGARET HARRISON, KAY HUNT AND MARY KELLY
(b.1940; 1933–2001; b.1941)

Margaret Harrison, Kay Hunt and Mary Kelly were all involved with British feminist groups in the 1970s. In 1973 they collectively embarked on a two-year research project to expose inequality among the working-class employees of a metal box factory in Bermondsey, London.

They photographed the women who worked there and accumulated punch cards detailing hours worked and pay grades, oral narratives of conditions in the factory and film footage. *Women and work: A document on the division of labour in industry* was first exhibited in 1975 at the South London Art Gallery. It revealed that women were pushed into lower-graded work while all the top jobs were held by men. 'In the 1970s I was quite comfortable about producing work which was seen as deeply political at the time,' Harrison reflects. 'I just saw it as part of life. Photography and documentation weren't seen as art and we were criticised for producing this work which was not just for decoration but went more into the subject matter.'[34]

Critics found the documentary nature of the installation hard to grasp as art but the immediate political impact was clear – all three artists were banned from ever entering the metal box factory again.

Women and work: A document on the division of labour in industry 1973–5
Video (2 monitors, colour, audio) and photographs;
gelatin silver prints on paper and works on paper, ink
Dimensions variable

MARY KELLY
(b.1941)

Mary Kelly was one of the most significant voices in the women's movement in the UK in the 1970s. She moved to London from America in 1968; five years later, while pregnant with her son, she decided to record the psychological effect of becoming a mother. *Post-Partum Document* was the result, an installation of 135 elements grouped into six sections that analysed the role of the mother in the growth and development of her child from birth to age five. 'It is not a traditional narrative,' Kelly explains; 'a problem is continually posed but no resolution is reached. There is only a replay of moments of separation and loss, perhaps because desire has no end, resists normalisation, ignores biology, disperses the body.'[35]

When *Post-Partum Document* was first exhibited it caused critical meltdown, largely due to Kelly's use of soiled nappy liners. She had used the liners as a base on which to record how she weaned her son ('1.15 hrs 6 tsps carrot'; '15.00 hrs 2½ ozs Ribena'). She also used his baby vests and first words, fragments of his comforter, theoretical diagrams and her own diaristic commentary. The viewer feels the tedium, the elation, the physical endurance of raising a small child. We are inside the experience rather than on the outside looking in.

Post-Partum Document 1973–9
Mixed media
Dimensions variable

JUDY CHICAGO
(b.1939)

In 1979 Judy Chicago completed her most ambitious installation to date: *The Dinner Party*. Six years in the making, it featured a giant triangular table laid for a sumptuous banquet. There were thirty-nine named guests, each with their own hand-embroidered table runner, gilded chalice and ornate porcelain plate. Sappho and Sacajawea were invited, along with Isabella d'Este, Georgia O'Keeffe and Virginia Woolf. A further 999 women are named on the white tiled floor under the table. It is a roll-call of powerful and important women, a 'herstory' to counter history. '*The Dinner Party* was my attempt to redress this imbalance of history,' says Chicago, 'to provide women with symbolic proof of our importance, our struggle and our proud heritage.'[36]

Chicago has described *The Dinner Party* as 'a sort of Last Supper told from the point of view of those who did the cooking throughout history, whose ideas were consumed by rather than preserved by the culture.'[37] Despite its scale, *The Dinner Party* initially toured sixteen venues in six countries and was seen by over a million people.

The Dinner Party 1974–9
Ceramic, porcelain and textiles
1463 × 1463

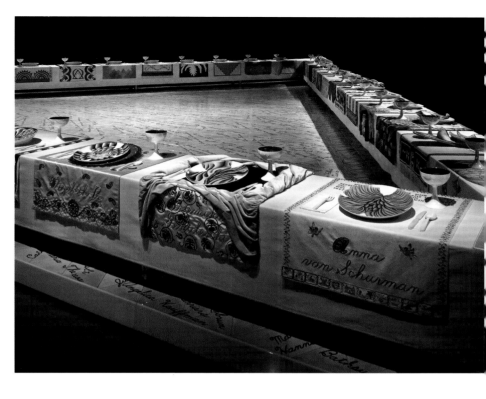

CAROLEE SCHNEEMANN
(1939–2019)

Interior Scroll exists today as a print made to document Carolee Schneemann's performance from August 1975, when she participated in the *Women Here and Now* exhibition in East Hampton, New York. For an audience of largely women artists Schneemann undressed, wrapped herself in a sheet, climbed on a table and read from her book, *Cézanne: She was a Great Painter*. She then dropped the sheet and brushed dark paint over her face and body. Finally she pulled a long scroll of paper from inside her vagina, from which she read a text transcribed from her 1973 film *Kitch's Last Meal*. The narrative was of a meeting between a male filmmaker and Schneemann and explored their different approaches to filmmaking, with him dismissive of her concerns. The text concluded:

> He said we can be friends equally
> tho' we are not artists equally
> I said we cannot be friends equally
> and we cannot be artists equally[38]

In *Interior Scroll* Schneemann literally pulled words – meaning – from inside herself. Painting her body during the performance reinforced the idea that her body was the work of art. The nude was reclaimed as an active presence rather than offered up for passive viewing.

Interior Scroll 1975
Beetroot juice, urine and coffee on screenprint on paper
183 × 90.5

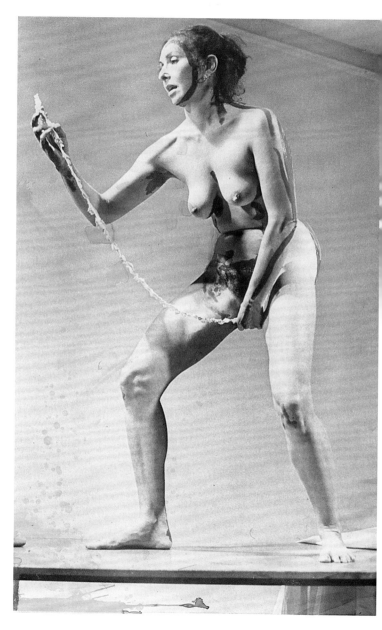

MARTHA ROSLER
(b.1943)

In 1975 Martha Rosler stood behind a kitchen table in a loft in New York and created *Semiotics of the Kitchen*. Lasting just over six minutes, the grainy black-and-white video shows Rosler, dead-pan, holding up a number of cooking implements and demonstrating their uses as she works her way from A to Z. Apron, Bowl, Chopper – the everyday kitchen utensils become sinister weapons as she smashes them down or stabs at the air, before using her body to represent the last few letters.

Semiotics of the Kitchen explores the social construct of domestic life and points to a coded system based on gender, reinforced by 1970s television shows and advertising. The video was created by Rosler a year after she graduated from the University of California in San Diego. Her early videos were not made for sale and were not editioned as she was keen for them to be seen as widely as possible. When *Semiotics of the Kitchen* was posted on YouTube one of her distributors wanted her to take it down. 'I said why?' she recalls. 'Why would a video artist want their work taken down? The whole point was to disseminate it.'[39]

Semiotics of the Kitchen 1975
Video; black and white, sound
6 minutes 9 seconds

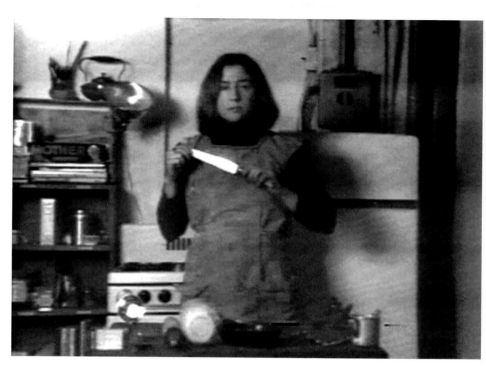

SANJA IVEKOVIĆ
(b.1949)

Sanja Iveković is credited with being the first artist in the former Yugoslavia to actively explore gender difference. She belongs to a generation of artists who came of age during the 1968 student protests. They formed the New Art Practice and used Pop sources and new technologies (film, photography, graphic design) to critique modernist art.

For the series *Double Life* 1975–6, Iveković juxtaposed images from magazines such as *Marie Claire* and *Grazia* with photographs taken from her private family albums, creating sixty-four pairings. The similarity of poses between the two sources would trigger the work. Had she subliminally adopted the poses of women seen in similar magazine photographs and adverts over the years? Had her reality been shaped by editors and businessmen?

While there are parallels between her work and other feminist artists working in Western Europe and America at this time, Iveković points out that the work took on a different meaning as it was made under socialist conditions. 'Nothing is free from ideology,' she says, 'and everything we do has a political charge. I asked myself how not to be a passive object of this ideological system, how to act and react. What is my relationship to power, domination, exploitation?'[40]

Double Life: November 1966 and "Grazia" 1975 1975
Black-and-white photograph on paper and printed paper on paper
80 × 60 (frame)

riviera adriatica

c'é un premio per i primi e anche per gli ultimi
(giugno e settembre a tariffe ridotte)

EMILIA ROMAGNA

Un mare pulito (53 miliardi spesi lo dispostrato) e tranquillo (con fondali dove i bambini possono giocare senza paura), una spiaggia larga a sabbiosa.

Antiche piante e 38.000 ettari di nuovi parchi attrezzati per lo svago e il riposo; la storia a 2 passi (monumenti romani, bizantini, medioevali e sui colli una corona di castelli); la conoscenza dei prezzi (tai prari e confermati).

Il folklore, l'artigianato, i piccati di gola sono permessa e l'amicizia di tutta una gente cordiale per sapersi non per calcolo.

Tutto questo cose assieme to la puoi offrire solo la Riviera Adriatica di Emilia-Romagna.

LIDI FERRARESI · RAVENNA E LE SUE MARINE · CERVIA/MILANO MARITTIMA · CESENATICO · GATTEO MARE · SAN MAURO MARE · BELLARIA/IGEA MARINA · RIMINI · RICCIONE · MISANO · CATTOLICA · TERME DI BAGNO DI ROMAGNA · BRISIGHELLA · CASTROCARO · RIOLO TERME.

l'Emilia Romagna ricambia chi l'ama
Regione Emilia/Romagna · Enti locali e turistici della Costa Emiliano Romagnola.

COSEY FANNI TUTTI
(b.1951)

Two years in the making, the COUM Transmissions exhibition *Prostitution* opened at the Institute of Contemporary Arts in London in October 1976. Pornographic images of Cosey Fanni Tutti lined the walls. Props from COUM performances were scattered around: bloody bandages and tampons, a rusty knife, a jar of Vaseline. The press went bananas, walkouts were staged and this controversial exhibition even provoked a debate in the House of Commons.

COUM was an experimental art collective founded by Genesis P–Orridge. The band Throbbing Gristle was the fruit of its loins but its controversial star was Cosey Fanni Tutti. She infiltrated the commercial pornographic industry and images from forty magazine spreads created over two years became the backbone of *Prostitution*. In the photographs she was posed for male titillation and was often naked. She argues: 'I project myself into the role of "model" knowing fully what is happening and what to expect. To me it is predictable. The only thing that invisibly sets me apart is my perception of things.'[41] How different she was from the other models is a matter of degree. Cosey continues to use her body and sex to make art and her work remains controversial.

Poster for *Prostitution*, Institute of Contemporary Arts, London 1976
Print on paper
29.7 × 21

October 19th-26th 1976

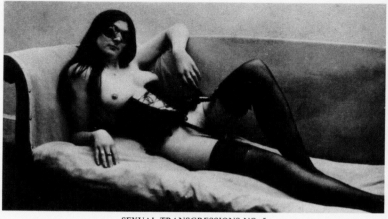

SEXUAL TRANSGRESSIONS NO. 5

PROSTITUTION

COUM Transmissions:- Founded 1969. Members (active) Oct 76 - P. Christopherson,
Cosey Fanni Tutti,Genesis P-Orridge.Studio in London.Had a
kind of manifesto in July/August Studio International 1976. Performed their works
in Palais des Beaux Arts,Brussels; Musee d'Art Moderne, Paris; Galleria Borgogna,
Milan; A.I.R. Gallery, London; and took part in Arte Inglese Oggi, Milan survey of
British Art in 1976. November/December 1976 they perform in Los Angeles Institute
of Contemporary Art;Deson Gallery,Chicago;N.A.M.E. Gallery,Chicago and in Canada.
This exhibition was prompted as a comment on survival in Britain,and themselves.

2 years have passed since the above photo of Cosey in a magazine inspired this
exhibition.Cosey has appeared in 40 magazines now as a deliberate policy.All of
these framed form the core of this exhibition.Different ways of seeing and using
Cosey with her consent,produced by people unaware of her reasons,as a woman and an
artist, for participating.In that sense,pure views.In line with this all the photo
documentation shown was taken,unbidden by COUM by people who decided on their own
to photograph our actions.How other people saw and recorded us as information.Then
there are xeroxes of our press cuttings,media write ups.COUM as raw material.All of
them,who are they about and for? The only things here made by COUM are our objects.
Things used in actions,intimate (previously private) assemblages made just for us.
Everything in the show is or sale at a price,even the people. For us the party
on the opening night is the key to our stance,the most important performance.We
shall also do a few actions as counterpoint later in the week.

PERFORMANCES: Wed 20th 1pm - Fri 22nd 7pm

Sat 23rd 1pm - Sun 24th 7pm

INSTITUTE OF CONTEMPORARY ARTS LIMITED
NASH HOUSE THE MALL LONDON S.W.I. BOX OFFICE Telephone 01-930-6393

LINDER
(b.1954)

In the year this photomontage was made, Linda Mulvey adapted
her first name and ditched the rest. She was still a student, studying
graphic design at Manchester Polytechnic, when Punk tore into the
city and Linder found her direction. She befriended the Buzzcocks
and music rippled through her life but it was her abandonment
of paint for the scalpel that shaped her art the most.

This untitled photomontage comes early in a series of
Untitled works that saw her dissect men's and women's magazines
and splice images together. Pornographic nudes were restyled
with irons or blenders for heads and naked women on all fours
were surrounded by glutinous tarts and pasties. Questioning the
commodification of the female body, Linder's fusion of women
and domestic goods can be uncomfortable to look at.

These works were influenced by the Dada montages of
Hannah Höch and the Pop collages of Richard Hamilton but were
driven by Linder's own preoccupations. As in this example eyes
were often blinded or skewered or heads entirely obliterated. Women
no longer return loving glances – their eyes swivel in burnt sockets
and look away. Linder's photomontages suggest that the gaze –
both depicted and applied – is never neutral.

Untitled 1976
Printed papers on paper
27.9 × 19.6

48

NANCY SPERO
(1929–2009)

Nancy Spero's *Torture of Women* is a work on an epic scale.
It is over thirty-eight metres long, a collage of texts and figures.
The texts are drawn from a range of sources including a 1975
Amnesty International report on torture, definitions of torture from
the last 700 years and newspaper articles. These texts, typed
or block-printed in black, red and yellow, are often fragmentary.
'Torture today is essentially a state activity', reads one, the bottom
of the typed sheet ripped as if pulled from a typewriter and silenced.
Other words tumble off the page – 'KNIFE CUT' – or shift uneasily
from letter to letter, the ink a blood-red confession.

Under, over and around the texts are drawings. There's
something intrinsically ancient about them even though they are
all drawn by Spero. There are Mesopotamian winged figures and
Egyptian hieroglyphics, multi-headed Hydras and mutilated torsos
littering the ground. All suggest that torture exists of its time and
for all time.

Spero's work often exposes political and social injustice and
Torture of Women makes for harrowing viewing. 'As I hung half-naked
several people beat me with truncheons' reads one text. The one
opposite states: 'were informed that she had committed suicide'.

Torture of Women 1976
Collage on paper
38.1 metres long

were informed that she
had committed
suicide .

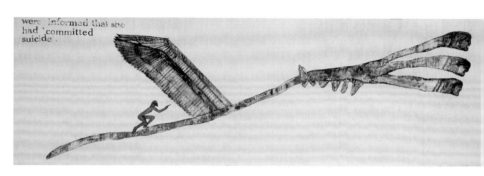

ROSE FINN-KELCEY
(1945–2014)

In 1976 Rose Finn-Kelcey staged a two-day performance at the Acme Gallery in London called *One for Sorrow Two for Joy*. Tree branches covered the gallery floor and two magpies hopped about. The artist perched in the plate-glass window singing a transcription of birdsong back to the magpies. 'I regard working from a codified – though non-verbal – text as analogous to my desire to find an appropriate voice for my experience as a woman artist,' she explains.[42]

Involved with the Women Artists Collective and a founding member of the Women Artists Slide Library, Finn-Kelcey was keen to give voice to the complexity of being a woman in a patriarchal world. This work explored the barrier between private and public: she performed inside the gallery but could be viewed from the street, where sounds from the installation were broadcast. At the same time the public–private relationship Finn-Kelcey explored was also a personal one. She referred to the magpies as her 'alter-ego sisters' and when she fed them she said it was like 'feeding my ego'.[43]

One for Sorrow Two for Joy 1976
38 photographs; 30 gelatin silver prints and 8 C-prints on paper, exhibition catalogue, printed papers and ink on paper
Dimensions variable

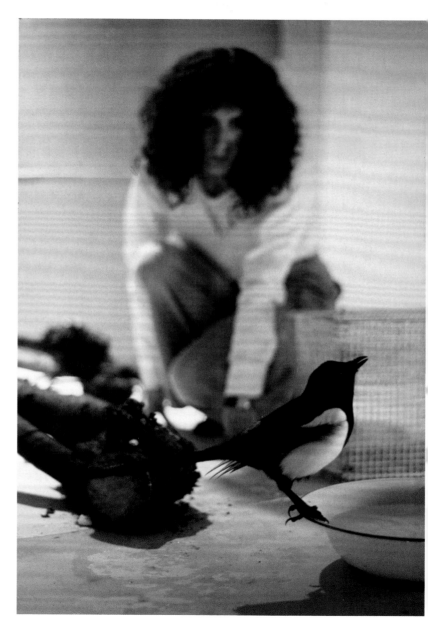

ALEXIS HUNTER
(1948–2014)

Alexis Hunter's *Approach to Fear* series (1976–81) is a collection of thirty sequential photoworks. The series ranges from desecrated images of male nudes to high heels on fire and often features a woman getting her hands dirty. 'I wanted to authenticate a form of art that incorporated feminist theory – images and presentation – that insisted on the female identity of the artist,' Hunter explains. This series 'investigated the value of feminism in conquering conventional female fears, such as technophobia, rape, grief, and objectified male sexual power'.[44]

Approach to Fear XVII: Masculinisation of Society – *exorcise* comprises ten photographs that look like film stills. In the first photograph a shadow of a woman's hand looms over a pin-up of a naked muscle-man, his hand wrapped around a substantial erection. In subsequent images the woman's hand proceeds to smear black ink over the man's crotch, again and again. The woman's touch could be seen as both erotic and violent, her obliteration of the man's sex in keeping with the crop on the photo that has left him without eyes, without identity. We can look at him but he cannot look at us.

(The image opposite is a test card for the final work and shows how Hunter manipulated the image to code it's reading. It has twice as many photos as the final work, the caption for which is below.)

Approach to Fear XVII: Masculinisation of Society – exorcise 1977
10 colour photographs mounted on two panels
101 × 25 (each panel)

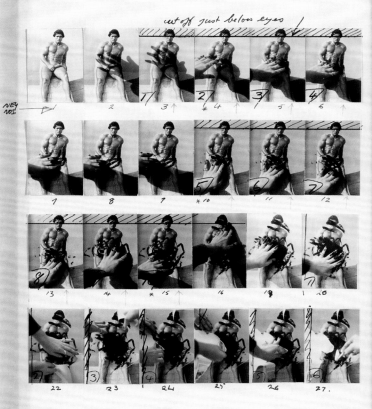

'Approach to Fear _XVII_ Masculinisation of Society - Exorcise'

cut off just below eyes

'77
ALEXIS HUNTER

TEST CARD

LAURIE SIMMONS
(b. 1949)

Laurie Simmons created her *Early Colour Interiors* series from her apartment in New York. She was juggling odd jobs while making art and preferred to work at home rather than in a studio. A few years earlier she had bought a dolls' house from a toy shop that was closing down. In 1976 she started photographing it and by 1978 she had switched to colour and added scale dolls.

Blonde / Red Dress / Kitchen / Milk is a claustrophobic image of a 1950s housewife in a floral dress standing in a model kitchen. It is six o'clock but there is no tea on the table; rather there is a mess of groceries, with dishes in the sink and pans on the stove. It is as if the woman has downed tools and stopped to think about what she is doing. Photographed from above in strong light the woman seems marooned, her eyes downcast. An ominous shadow looms on the left, adding to the creeping sense of unease.

Using colour allied these images with commercial photography. Simmons questions the role of the woman in the home and contrasts the projected perfection of advertised domestic bliss with the mundanity and isolation many experienced.

Blonde / Red Dress / Kitchen / Milk 1979
Photograph; colour Cibachrome print on paper
8.9 × 12.7

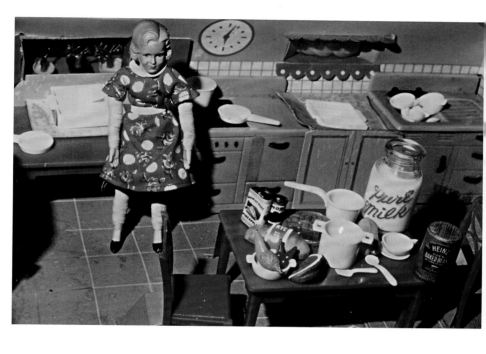

LYNN HERSHMAN LEESON
(b.1941)

Who was Roberta Breitmore? Born in 1974 as a fully-grown woman, she existed for a number of years until being officially 'retired' by the artist who created her, Lynn Hershman Leeson. In this time Breitmore was played by Leeson and three other women, all of whom adopted her personality, wore her clothes and carried her credit cards and driving licence.

Breitmore was an alter ego, a character through which Leeson exposed society's expectations and assumptions about women. She existed as a person but also through documents. In *Roberta's Body Language Chart* small black-and-white photos of Breitmore are analysed in type below. Do crossed arms mean she is 'frustrated'? Does pulling her skirt down reveal 'frigidity, fear of sex'? What can we actually tell from these photographs, purportedly taken during Breitmore's visit to her psychiatrist? 'By accumulating artefacts from culture and interacting directly with life,' Leeson says, 'she [Breitmore] became a two-way mirror that reflected societal biases absorbed through experiences.'[45]

Roberta's Body Language Chart 1978
Photograph; gelatin silver print on paper
102.6 × 85.3 (image)

"Americans show
greater differences
gesturally"

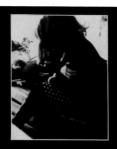

"Do crossed arms
mean that 'I am
frustrated?"

"A hand to the
face may serve
as a barrier"

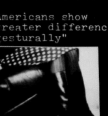

"Crossed legs point
to each other. "

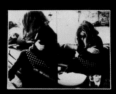

"Crossed arms do
the same thing"

"Crossing arms
defines posture"

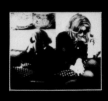

"Does she try to
avert attention
avoiding your eyes?"

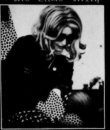

"Is she sitting
stiffly and not
relaxed?"

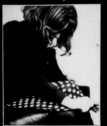

"Covering legs
reveals frigidity,
fear of sex."

ROBERTA'S BODY LANGUAGE CHART

(photographed during a psychiatric session)

January 24, 1978

CINDY SHERMAN
(b.1954)

In *Untitled Film Still #48* a woman stands in the middle of a road, demurely dressed in a gingham skirt with a small suitcase behind her. Sky and road stretch away but the flash catches on her platinum hair and white blouse and focuses our attention. She is turned away so we can project our thoughts on to her: where is she going? Is she running away? What is her back story? Her future?

The *Untitled Film Stills* series runs to sixty-nine photographs taken between 1977 and 1980. Cindy Sherman appears in every one. The photographs expose how female identities in films often rely on formulaic types: the dizzy starlet, the jilted lover, the working woman, the dreamy schoolgirl. 'I absorbed my ideas for the women in these photographs from every cultural source that I've ever had access to,' Sherman says, 'including film, TV, advertisements, magazines.'[46] Each character poses for the camera and therefore the viewer. There's an awareness that she will be looked at, that she is styled as the object of male desire. However, Sherman challenges our expectations by morphing from character to character, revealing the artifice of on-screen femininity. Not one 'version' is real; they are all constructs.

Untitled Film Still #48 1979 (reprinted 1988)
Photograph; gelatin silver print on paper
71 × 96

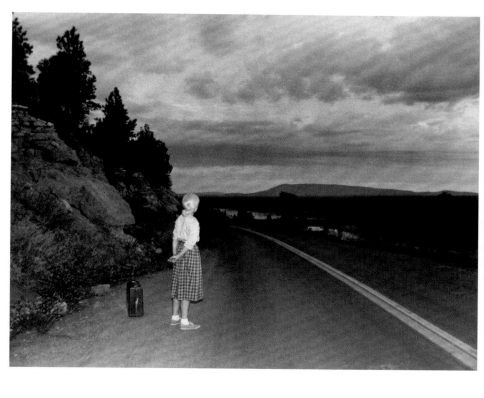

BARBARA KRUGER
(b. 1945)

Like many feminist artists of the 1970s, Barbara Kruger was drawn to using photography because it represented the antithesis of male creativity (large-scale painting and sculpture). She chose to use found black-and-white images, overlay them with pithy, bold statements printed in sans-serif fonts and display them in red enamel frames.

Untitled (Your gaze hits the side of my face) features a woman's head seen from the side. She cannot return our gaze so must absorb it. She is an object to be looked at, emphasised by Kruger's choice of a sculptural head with the plinth clearly visible.

Kruger's juxtapositions of words and pictures often contradict or make complex the image's original meaning. Kruger initially worked as a graphic designer and understands the power of signs to influence society. Stereotypical images – girls playing, male initiation ceremonies – are problematised by text: 'You make history when you do business'; 'We will no longer be seen and not heard'. In Kruger's own words she wishes to 'welcome the female spectator into the audience of men', and 'to ruin certain representations'.[47] Gender is constructed and produced, not born, and no image is neutral. 'Your body is a battleground', she attests.

Untitled (Your gaze hits the side of my face) 1983
Photostat, red painted wood frame
140 × 104

Your gaze hits the side of my face

JO SPENCE
(1934 – 1992)

Jo Spence founded her own photo agency in the 1960s, specialising in weddings and family portraits, but by the mid-1970s she had become interested in documentary photography. She used her own body as a weapon, fighting photography's representation of women as neat pre-ordained stereotypes: housewife, pin-up, bride.

Remodelling Photo History is a series of three images that challenges society's expectations of women. Spence takes on different roles and turns them on their head. In *Remodelling Photo History: Colonization* she stands on a doorstep, hand proprietorially on a broom like the man holding the pitchfork in Grant Wood's *American Gothic* 1930. Despite the domestic accents – milk bottles, outside light – we are drawn to her body. She is wearing a sarong, beads, watch and sunglasses but her breasts are exposed and her feet are bare. She conflates the role of a dutiful housewife sweeping the step with a 'Readers' Wives' eroticism. Women cannot be pigeon-holed into any one category, she asserts.

Spence questions the stereotypes often projected by advertisements and our ready acceptance of the lies they offer up as truths. There are fictions at play and Spence enjoys exposing them, often with earthy humour and bravery.

Remodelling Photo History: Colonization 1981–2
Photograph; tinted gelatin silver print on paper; collaboration with Terry Dennett
70 × 50

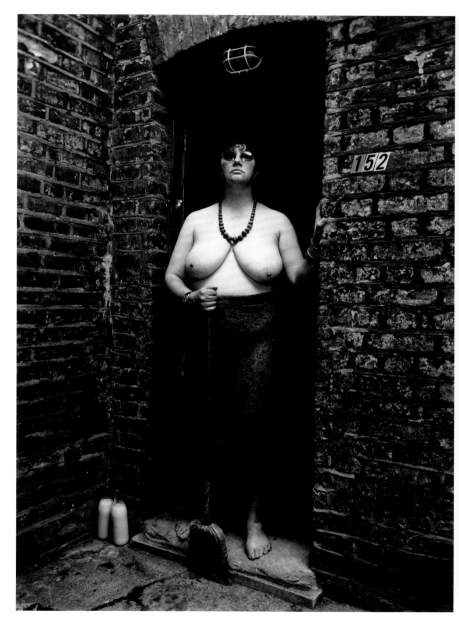

LUBAINA HIMID
(b.1954)

Lubaina Himid is a force of nature. 'I think of myself as a painter but at the same time as a cultural activist,' she says.[48] She is also a writer, curator and professor, a pioneer of the Black Arts Movement in 1980s Britain and the first Black woman to win the Turner Prize (in 2017).

Freedom and Change was made in 1984, a year before she curated the influential exhibition *The Thin Black Line* in London. Two Black women charge across a pink banner, their multicoloured dresses whipped up by the wind, four dogs on leads pulling them forwards. The printed earth beneath their feet has been churned up and now nearly buries two white men who splutter in their wake. These women are reclaiming their place in history – a history long dominated by white men. In *Freedom and Change* Himid reworked Picasso's *Two Women Running on the Beach (The Race)* 1922, reclothing the models and spurring them on. Much of her work is based on supplanting colonial histories for Black ones, whether by repainting willow-pattern plates with slave stories or appropriating modernist paintings to amplify her own voice.

Freedom and Change 1984
Plywood, fabric, acrylic paint and other materials
290 × 590

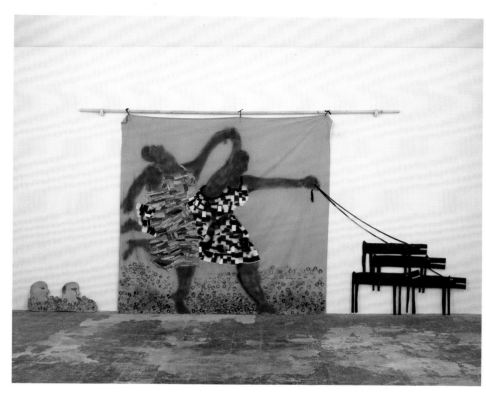

SUZANNE LACY
(b. 1945)

On Mother's Day in 1987 a large shopping mall in Minneapolis became the stage for an hour-long performance, the culmination of a three-year project by Suzanne Lacy. Four hundred and thirty women sat at tables of four. Every ten minutes the women's hands moved to a different configuration as a soundtrack by Susan Stone played to a 3,000-strong crowd, who viewed the performance from above.

The Crystal Quilt was Lacy's most ambitious work to date. 'It is a very complex strategy around two themes,' she explains. 'One is the visibility or invisibility of older women and the other is their leadership capacity.'[49] The project involved women over sixty and featured art exhibitions, lectures and seminars. A quilt, made to mark the performance and symbolise the collaborative aspect of the project, was based on a painting by Miriam Shapiro that had been used as a backdrop.

Lacy's work often involves partnerships and she complements an action or performance with practical workshops and lectures. An early work from 1978, *In Mourning and in Rage*, featured a staged funeral cortège to protest at a spate of recent rapes and murders in Los Angeles.

The Crystal Quilt 1985–7
Cotton quilt, 36 photographs, signed poster, recording of performance
soundtrack on tape, single-screen video documentary with audio,
duration 50 minutes, single-screen 16mm film projection (duration 2 minutes)

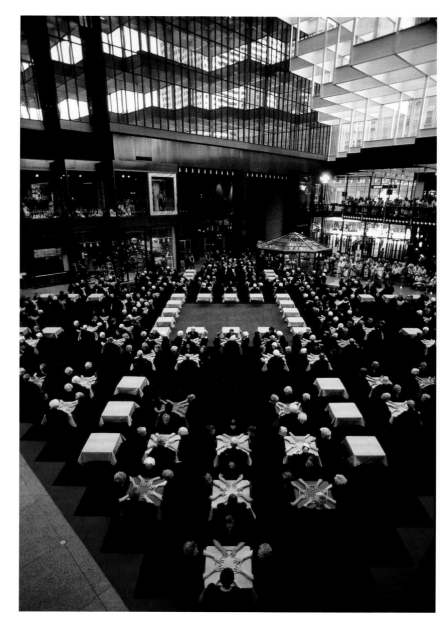

ADRIAN PIPER
(b.1948)

In 1986 Adrian Piper printed two boxes of business cards: one on white card and one on brown. The white cards were to fend off unwanted admirers and argued that just because she was on her own – in a bar, at a nightclub – she did not want to be chatted up. The brown card she handed out whenever she heard a racist slur. As a light-skinned African-American she was often mistaken for white, and the card began: 'Dear Friend. I am black. I am sure you did not realize this when you made / laughed at / agreed with that racist remark.' The cards have subsequently been offered to visitors at her exhibitions under the heading: 'Join the struggle, take some for your own use.'

My Calling (Card) is a conceptual riposte to prejudice. Piper uses her body for performances and to investigate an 'awareness of the boundaries of my personality'.[50] Her works are often created in the real world, rather than a gallery setting and provoke reactions from those who unexpectedly experience them. This is her key reason to undertake them: to induce a change in the viewer.

My Calling (Card) #1 (for Dinners and Cocktail Parties) 1986–present
My Calling (Card) #2 (for Bars and Discos) 1986–present
Performance utensils: business cards with printed text on cardboard
5.1 × 9 (each)

Dear Friend,
I am black.

I am sure you did not realize this when you made/laughed at/agreed with that racist remark. In the past, I have attempted to alert white people to my racial identity in advance. Unfortunately, this invariably causes them to react to me as pushy, manipulative, or socially inappropriate. Therefore, my policy is to assume that white people do not make these remarks, even when they believe there are no black people present, and to distribute this card when they do.

I regret any discomfort my presence is causing you, just as I am sure you regret the discomfort your racism is causing me.

Dear Friend,

I am not here to pick anyone up, or to be picked up. I am here alone because I want to be here, ALONE.

This card is not intended as part of an extended flirtation.

Thank you for respecting my privacy.

HELEN CHADWICK
(1953-96)

Helen Chadwick's most ambitious installation, *The Oval Court*, was the centrepiece of her touring show *Of Mutability*, which started out at the Institute of Contemporary Arts in London in 1986. It was made using an office photocopier filled with blue toner. Chadwick collaged photocopies of her own naked body alongside those of a swan, a lamb and a ray, surrounding them with bushels of wheat and armfuls of flowers. The figures look as if they are underwater. Five gold spheres float on the surface while decorative columns topped with portraits of Chadwick crying leafy tears line the walls.

Chadwick constantly explored what it was to be a woman in the world. In *The Oval Court* it was as if only women remained, embracing nature in private mythological narratives. There is a latent sexuality to the work – the suggestive underbelly of the ray, the sinuous curves of 'Leda' and the swan, Chadwick gorging on fruit. 'I want to catch the physical sensations passing across the body – sensations of gasping, yearning, breathing, fullness,' she says. 'Each of them is completely swollen up with pleasure at the moment when it's about to turn, each has reached the pitch of plenitude before it starts to decay, to empty.'[51]

The Oval Court 1986
Photocopies using cyan powder toner, turned plywood finished with gesso, gold size and gold leaf
Dimensions variable

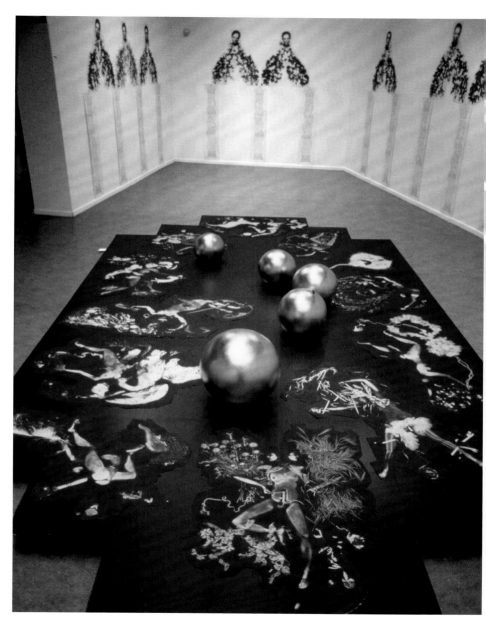

LEE BUL
(b.1964)

Lee Bul's early works were performances, staged around Seoul wearing complex home-made costumes covered in strange protuberances and growths. *Untitled (Cravings White)* was Bul's costume for her 1989 performance *Cravings.* (It was remade in 2011 after the original was lost in a studio flood.) There's a dreamlike quality to the outfit's anthropomorphic and uncanny form, reminiscent of Yayoi Kusama's 1960s *Accumulations*. It now exists as an object but looks like it may spring to life at any moment, the tubers grasping like needy hands.

Bul's early performances were held on the street or on parched ground, as with *Cravings*. Hidden microphones inside the costume amplified the sound of her body scuttling over the land. In other early performances she discussed the humiliation of being a woman in a patriarchal society. She wanted to challenge the expectations imposed on South Korean women and the costumes she constructed and wore were often inflated to the level of grotesque. Lee is interested in the monstrous, in that which 'exceeds prescribed boundaries'.[52]

Untitled (Cravings White) 1988 (remade 2011)
Fabric, acrylic paint, wood, stainless-steel carabiner and stainless-steel chain
244 × 155 × 95

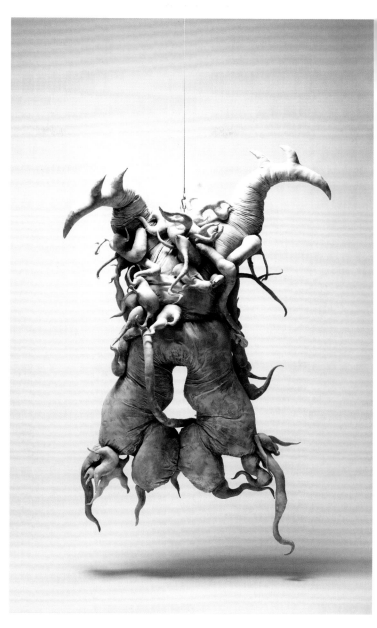

MONA HATOUM
(b.1952)

Mona Hatoum was in London when war broke out in the Lebanon in 1975. The daughter of Palestinian parents, she had grown up in the Lebanon but was unable to return and has lived in London ever since.

In *Measures of Distance* blurry images of Hatoum's mother showering appear behind a screen of Arabic words. The artist and her mother can be heard chattering away, their conversation recorded during a visit home. Punctuating this dialogue are letters read by Hatoum that her mother had sent her from Beirut.

The video speaks of exile, nostalgia and a deep sense of loss. 'I was also trying to go against the fixed identity that is usually implied in the stereotype of Arab woman as passive, mother as non-sexual being,' Hatoum says.[53] Her mother's letters tell of her frustration at life being out of her control, with all of her daughters living abroad. It also gives a view of a rigid underlying patriarchy. Hatoum's father discovered them taking photos for *Measures of Distance* in the bathroom, both naked: 'We laughed at him when he told us off,' her mother writes, 'but he was seriously angry. He still nags me about it, as if I have given you something that only belongs to him.'

Measures of Distance 1988
Video projection; colour and sound (mono)
15 minutes 26 seconds

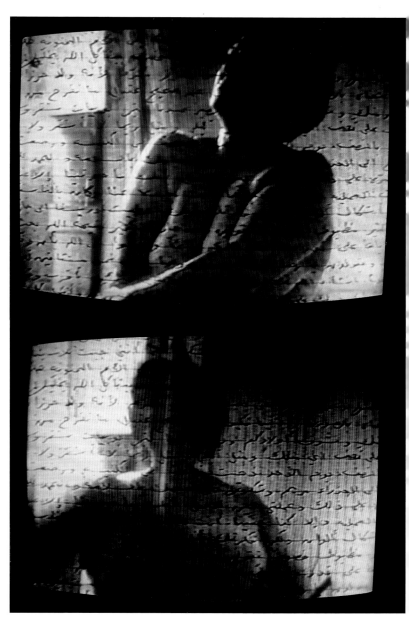

GUERRILLA GIRLS
(founded 1985)

The Guerrilla Girls burst on to the New York art scene in 1985. They were dreamt up by a group of practising women artists who wanted to reactivate feminism. They appropriated the (male) language of advertising and took their message to the streets, fly-posting pithy texts that challenged museums to display more works by women and non-white artists and criticised commercial galleries for their racial and sexual discrimination.

Do women have to be naked to get into the Met. Museum? was originally commissioned as a billboard project by the New York Public Art Fund. The mock-up of the Guerrilla Girls' poster was rejected so they funded the project themselves, and Ingres's *La Grande Odalisque* 1814, now sporting a gorilla mask, sped around the city on the side of New York buses. The Guerrilla Girls later released the work as part of their print portfolio *Guerrilla Girls Talk Back*.

The Guerrilla Girls maintain their anonymity even when running 'gigs' (workshops and lectures) by wearing gorilla masks throughout public events and adopting the names of dead women artists, such as Frida Kahlo and Käthe Kollwitz. The anonymity of the group serves to focus attention on the group's ideas and not individuals, a collective non-hierarchical approach that still exists in the group to this day.

Do women have to be naked to get into the Met. Museum? 1989
Screenprint on paper
28 × 71

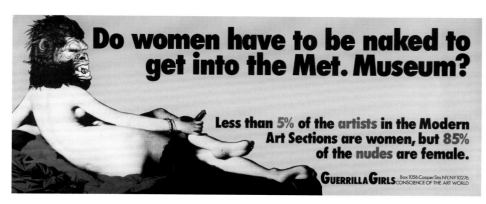

Do women have to be naked to get into the Met. Museum?

Less than 5% of the artists in the Modern Art Sections are women, but 85% of the nudes are female.

GUERRILLA GIRLS Box 1056 Cooper Sta. NY, NY 10276
CONSCIENCE OF THE ART WORLD

XIAO LU
(b. 1962)

Xiao Lu's *Dialogue* was included in the 1989 exhibition *China/Avant-garde* in Beijing. Spontaneously, on the day of the opening, Xiao Lu decided to add to it by staging a performance, roping in a friend to photograph her in action. Catching the gallery staff unawares, she shot two bullets into the mirror between the phone boxes, fracturing it. The performance became legendary for highlighting the existence of contemporary women artists in China.

Initially Xiao Lu didn't see *Dialogue* as a feminist work, despite its origins. She attributes the work to not being able to talk honestly with her boyfriend about her past, which involved sexual abuse. Later in her career she immersed herself in feminist theory and expanded her practice to explore the experiences of other women. 'I think "women's rights" has many layers of meaning,' she says. 'First, a woman must find her own value and retain her independence … [and] women must be empowered. In China, the world of critics consists exclusively of men and they are the ones who have the authority to speak. So when a woman encounters an issue, she has nowhere to turn to, no one will listen to her.'[54]

Dialogue 1989. Remade 2015
Installation and performance

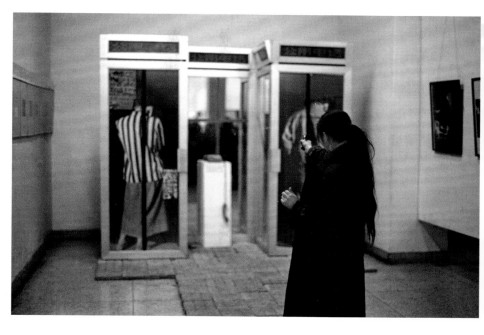

LOUISE BOURGEOIS
(1911–2010)

Louise Bourgeois was one of the first women artists to enjoy major (if belated) success as a result of the art world opening up to women in the 1980s and 1990s. *Cell (Eyes + Mirrors)* is one of a series of installations she built from salvaged architectural items, found objects and sculptural forms. We can only enter the space visually, using our eyes. Unexpectedly, black marble eyes stare back at us, challenging us. Our own gaze is reflected in the many mirrors inside the cell and becomes uncertain and fragmented. Is this cell a place of refuge or a prison?

There is always tension in Bourgeois's work, here created by the black eyes returning our voyeuristic gaze and the use of wire to create the walls of a room that simultaneously offers no sanctuary and no escape. 'The subject of pain is the business I am in,' Bourgeois says. 'To give meaning and shape to frustration and suffering ... The Cells represent different types of pain: the physical, the emotional and psychological, and the mental and intellectual.'[55]

Cell (Eyes + Mirrors) 1989–93
Steel, limestone and glass
236 × 211 × 218

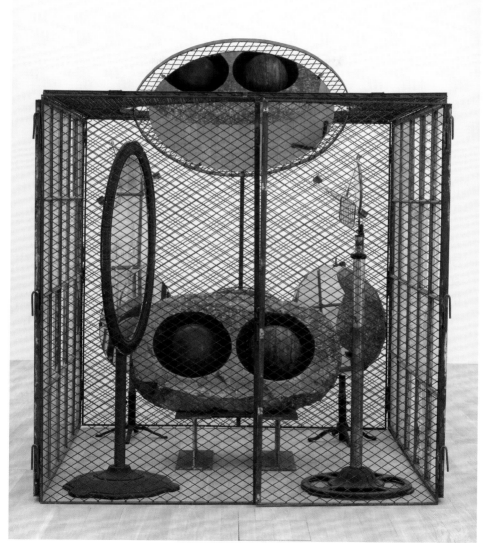

NAN GOLDIN
(b.1953)

Nan Goldin's *Misty and Jimmy Paulette in a taxi, NYC* was photographed in a yellow cab as Goldin's two friends travelled to New York's Pride Parade in 1991. The two drag queens were dressed to the nines in wigs, padded bras and heavy make-up yet their serious, almost melancholy, expressions give this image a mesmeric quality. We notice the human details – the rents in the fishnet top, the taxi's dirty rear window – as well as the desire to escape into a parallel world of excess, glamour and false eyelashes.

Goldin's fascination with the drag world began when she was a student at the Boston School of Art in the 1970s. She continued to photograph those around her when she moved to New York in 1978, creating moving images of relationships, candid scenes of sex and drug use and stark portraits of friends dying from AIDS, most notably in *The Ballad of Sexual Dependency* (1979–86).

In the 1990s her work was often associated with a wider definition of feminism as she explored new territory beyond the traditional male-female binary split. In 1993 she spoke of drag queens as being part of a more fluid gender category: the third gender. In her influential book *The Other Side*, dedicated to her photographs of the drag world, she said: 'I never saw them as men dressing up as women, but as something entirely different – a third gender that made more sense than either of the other two.'

Misty and Jimmy Paulette in a taxi, NYC 1991
Photograph; dye destruction print on paper mounted on board
69.5 × 101.5

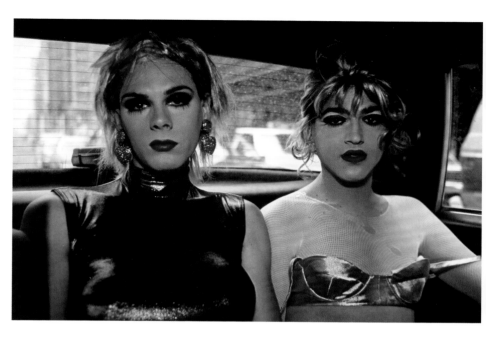

JENNY SAVILLE
(b.1970)

The history of the nude is overwhelmingly one of male painters and female models. This is just the territory Saville upended in the 1990s with her vast fleshy canvases of her own naked body. 'The history of art has been dominated by men living in ivory towers, seeing women as sexual objects,' she says. 'I paint women as most women see themselves. I try to catch their identity, their skin, their hair, their heat, their leakiness.'[56]

Propped features Saville perched on a high stool, larger than life-size, looking down at the viewer. Her arms are crossed over her breasts, her shoulders are hunched and her fingers claw uncomfortably at her thighs. Across the surface mirror-writing is carved into the paint. It's a quote from French feminist Luce Irigaray: 'If we continue to speak this sameness, if we speak to each other as men have spoken for centuries, as they taught us to speak, we will fail each other. Again.'

Propped became the most expensive work by a living woman artist to be sold at auction, selling for £9.5m at Sotheby's in 2018.

Propped 1992
Oil paint on canvas
213.5 × 183

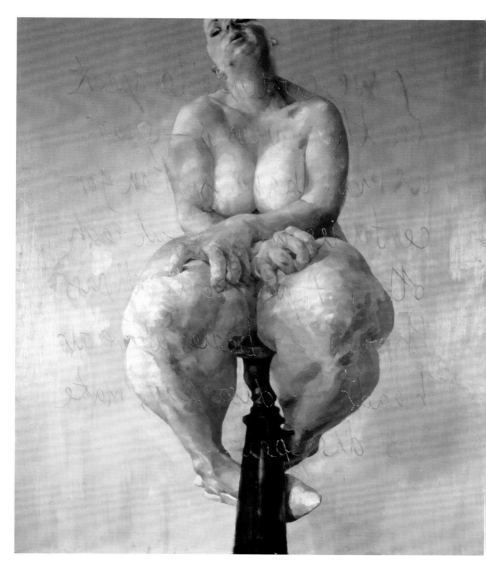

KIKI SMITH
(b.1954)

A life-size sculpture of a woman stands in a gallery. She has no hair, no eyes, no skin, and her muscles are pulled taught across her belly and above her breasts. She is an écorché, a wax model similar to the ones once used to teach anatomy.

Kiki Smith titled this sculpture *Virgin Mary*, and with this the mannequin takes on a deep and coded history. Smith was raised a Catholic but her own relationship with religion is one of searching. Ultimately she cannot commit to the stories; the characters are just people at the end of the day.

Smith's feminism is latent, a subtext that ripples through her work. Her sculptures, prints and drawings are centred on the figure in all its visceral splendour. In this work (which predated Chris Ofili's *The Holy Virgin Mary* 1996 by four years) she shows us the reality of those we venerate: a fleshy concoction of muscle and bone. In other works she uses human hair or casts spinal columns in glass to evoke the fragility of the body. She reveals the body as it is, beyond the socio-political and religious agendas that shape it.

Virgin Mary 1992
Wax, cheesecloth and wood with steel base
171.5 × 66 × 36.8

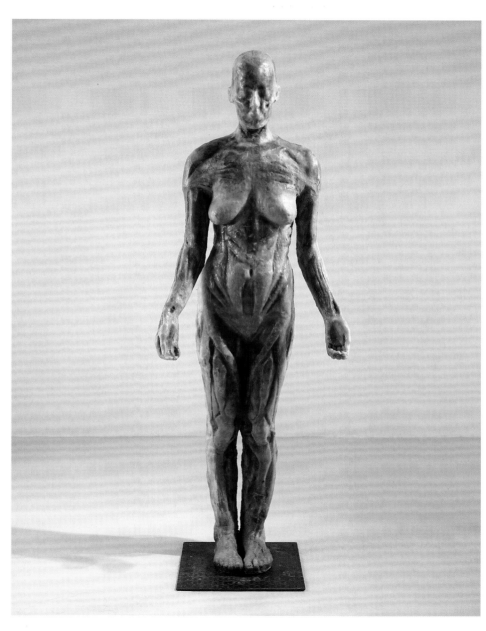

SHIRIN NESHAT
(b.1957)

In Shirin Neshat's *Rebellious Silence* a woman in a black chador stares out at the viewer, her dark eyes unafraid, resolute. The muzzle of a rifle bisects her face and lines of Farsi roll across her cheeks and forehead. To Western eyes the Farsi can seem illegible or decorative. To others it spells out the words of a martyrdom poem written by the female poet Tahereh Saffarzadeh whose words are written into the flesh of the gun-toting woman. The Western presumption that the hijab and chador supress Islamic women is brought into question in this work, just as Neshat questions any binary reading of Iranian society in the wider series *Women of Allah*.

Neshat was born in Iran but has lived and worked in America since the 1979 Iranian Revolution. Her transnational existence connects her to two cultures while rooting her in neither. As she says: 'Every Iranian artist, in one form or another, is political. Politics has defined our lives. If you're living in Iran, you're facing censorship, harassment, arrest, torture, at times execution. If you're living outside like me, you're faced with a life of exile, the pain of the longing and the separation from your loved ones and your family.'[57]

Rebellious Silence from the series *Woman of Allah* 1994
Resin-coated print and ink on paper
118.4 × 79.1

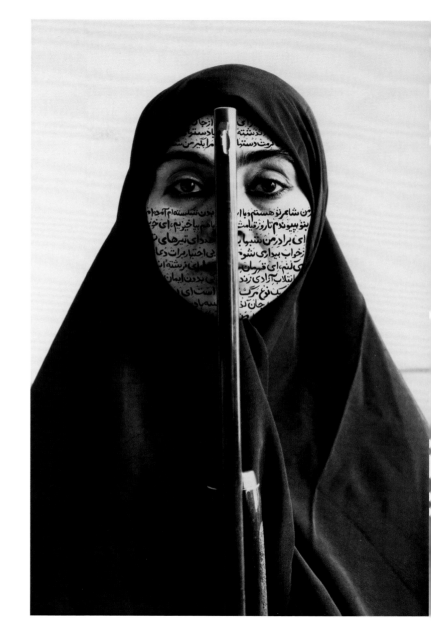

TRACEY MOFFATT
(b. 1960)

A girl in shorts and sandals crouches in front of a car. She polishes a headlamp while looking up at someone (or something) out of shot. Her face is serious, worried even. The image transports us back in time, to memories or a nostalgic imagining of the past, the past seen in old family photographs. However, the title adds a dark gloss – *Useless, 1974* – and the caption further seeds the image with fear: 'Her father's nickname for her was "Useless".'

Moffatt made nine lithographs in the series *Scarred for Life*. They are set historically, in the time of avocado bathroom sets, chrome bodywork and family secrets. A naked man threatens a young girl on a double bed; two boys are caught playing with dolls; a teenager finds out the name of her real father during a family argument. 'If it becomes a little terrifying then I'm interested,' Moffatt says.[58] The captions give these images a documentary edge but everything is staged, from Moffatt's use of actors to her construction of each scene. She works like a director and these carefully framed images ask questions of those who shaped entire lives with their unthinking remarks or preconceived gendered notions of acceptable behaviour.

Useless, 1974 from the series *Scarred for Life* 1994
Colour lithograph on paper
80 × 60

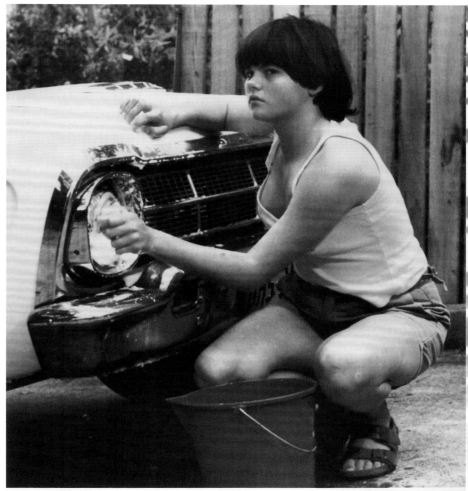

Tracey Moffatt

Useless, 1974

Her father's nickname for her was '*useless*'.

CARRIE MAE WEEMS
(b.1953)

Carrie Mae Weems's photographic work explores sexism and racism faced by African-Americans – both historically and today. *From Here I Saw What Happened and I Cried* features thirty-three historic photographs of Black men and women, the majority of which have been appropriated from a series of daguerreotypes of former slaves taken by the Harvard scientist Louis Agassiz in 1850. While Agassiz's name has been passed down through history, the names of those he photographed have not. Instead they were initially photographed as 'types', presented full-frontal and in profile, others standing stiffly in the uniform of their employer or photographed nude.

Weems overlays each image with text: 'You became a scientific profile', says one; 'You became playmate to the patriarch', reads another. By representing these figures individually and on a larger scale Weems goes some way to restoring their identity. 'There are three narratives that are working simultaneously,' she says of this work. 'You have this narrative that runs across the entire work [and] images that lay out a very specific development of history: of photographic history in the United States and of black history in the United States.'[59]

From Here I Saw What Happened and I Cried 1995–6
33 photographs; digital C-prints on paper and sandblasted text on glass
Dimensions variable

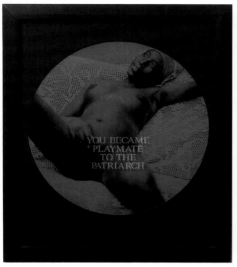

SARAH LUCAS
(b.1962)

Self-Portrait with Fried Eggs is a satirical riposte to female
bodies in art. Lucas sits in an old chair on a dirty chequered floor.
Legs spread, Marlboros to hand, eyes locked on the viewer, she
contradicts male expectations of a woman as something to be
looked at or objectified for their own pleasure. In this image Lucas
is in control, playing with bodily exposure and substituting sunny-
side-up eggs for breasts.

The photograph is one of a series of twelve self-portraits.
Ongoing themes are evident: a substitution of vegetables and food
for body parts, a use of everyday 'readymades' such as tights and
cigarettes, and a confrontational sense of humour. The photographs
show her eating a banana (p.15), squatting on a toilet and posing
in front of a washing line full of knickers. 'I never liked being in
photographs and I avoided it if at all possible,' she says. 'I thought
I looked masculine … But in that picture with the banana, the first
of those photos, you can see that those considerations of whether
you looked particularly good that day, or whether or not you look
a bit more masculine than you like to look, were in the service of the
picture. They weren't in the service of vanity.'[60]

Self-Portrait with Fried Eggs 1996
Digital print on paper
75 × 51

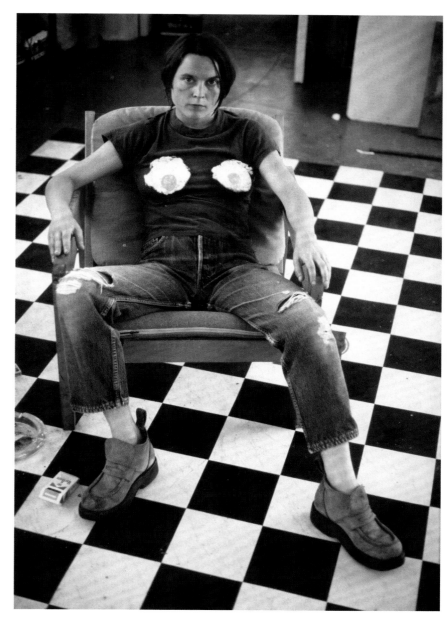

PAULA REGO
(b. 1935)

On a metal bed a woman in a checked dress lies curled up on her side, eyes open, fist clenched. She doesn't see the other two women who occupy similar territories: the smartly dressed one lying on a bed, legs apart, arms braced, or the schoolgirl squatting on a bucket. Together they form *Triptych*, part of a body of work that Paula Rego created in response to Portugal's referendum on whether to legalise abortion in 1998. Not enough people voted and abortion remained illegal (until 2017).

Rego, who grew up in Portugal, was incensed. She immediately began a series that didn't sugar-coat the reality of the alternative: back-street abortions. She has lived in London since 1976 but was angered by her birth country's apathy. 'I thought this can't do, it makes you absolutely enraged,' she says. 'I wanted to do something about it so I did these pictures of girls having abortions.'[61]

While Rego's women suffer they are not victims. They often look out at the viewer, lips set and eyes unwavering. They know what they are doing and why. It is their choice. It takes two to get pregnant but the woman always has to endure the pain – mental and physical – if it is terminated.

Triptych 1998
Pastel on paper, mounted on aluminium
110 × 100 (each)

 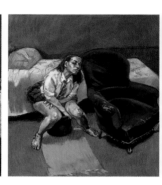

SONIA BOYCE
(b.1962)

What do 'My Boy Lollipop', 'Manchild' and 'Diamonds are Forever' have in common? They are all songs released by Black British women. Sonia Boyce has spent the last twenty years building an archive of music by such women, a project that began at Liverpool's FACT (Foundation for Art and Creative Technology) gallery in 1999.

Boyce has worked collaboratively since the late 1980s, no longer painting or drawing images of Black men and women to question racial stereotypes but working directly with various groups and organisations. Her *Devotional Collection* grew out of her collaboration with the group Liverpool Black Sisters. Boyce asked them to name Black British women in music who had influenced and inspired them. The initial list was added to by friends and family and grew by word of mouth. Boyce is still adding to it whenever people give her new names: there are over three hundred currently on the list and one thousand items relating to their music are held by Boyce in a growing archive. 'As an artist, I can keep a fluid relationship between an institutional structure like an archive and an art practice,' she says. 'The process is also about making collective knowledge apparent.'[62]

Devotional Collection 1999–ongoing
Archive of music, ephemera and wallpaper
Dimensions variable

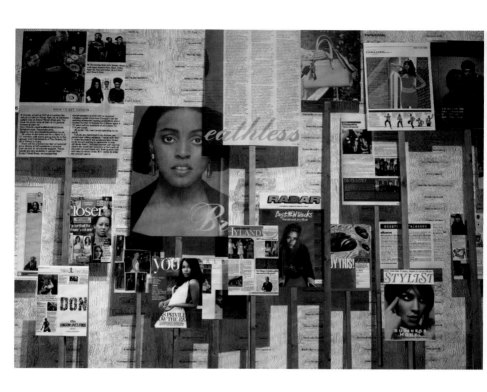

ZANELE MUHOLI
(b.1972)

As an artist and activist, Zanele Muholi has campaigned for the rights of Black lesbians and the African LGBTI community, using photography to document their lives and experiences. 'I have seen people speaking and capturing images of lesbians on our behalf, as if we are incapable and mute,' Muholi says. 'I have witnessed this at Gay Pride events, at academic conferences, in the so-called women's movement forums … I refused to become subject matter for others and to be silenced.'[63]

The series *Only Half the Picture* 2003–6 offers an intimate exploration of the LGBTI community in South Africa. Bodies are bound and manipulated, private pleasures indulged and scars exposed. In *In-security* 2003 a woman stands in cargo pants and boots, her tough clothing at odds with her defensively crossed arms. We don't see her face, only the wrinkles in her military-style trousers and the shadowy 'V' of her crotch.

In the notable series *Somnyama Ngonyama* (*Hail the Dark Lioness*) 2014 (see p.16), Muholi reacted to the prejudices they face as a Black lesbian by taking 365 mesmeric self-portraits over the course of a year.

In-security 2003 from the series *Only Half the Picture* 2003–6
Photograph; gelatin silver print on paper
48 × 33

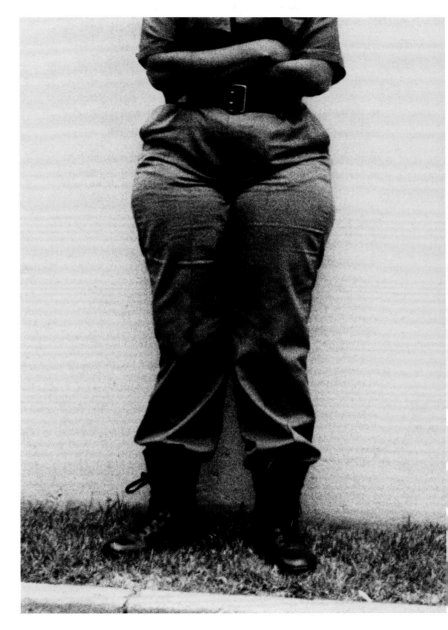

ZARINA HASHMI
(b. 1937)

Zarina Hashmi (who prefers to be known by her first name only) left India in 1958, travelling around the world for twenty years with her diplomat husband. She now lives and works in New York but at the heart of her practice is her childhood home, lost following the partition of India when her family moved from Delhi (India) to Karachi (Pakistan).

Zarina's work often centres around the dislocation felt when home is far away or only lives in memories. In *Letters from Home* she printed her sister Rani's letters, written in Urdu, on handmade Kozo paper. The letters told of family deaths in Pakistan. These are overlaid with a variety of maps that serve as an autobiographical journey through Zarina's life. Manhattan Island and the streets that once surrounded her childhood home both appear, as does the simple silhouette of a house. 'Maps and the memory of homes hold an inextricable significance in the life of a traveller,' she says. 'With a map, I can revisit the city I knew by tracing the streets and rivers. Home is always an interior reality, which, with a floor plan, I can walk through again and again in my imagination.'[64]

Letter II and *Letter VII* from *Letters from Home* 2004
Portfolio of 8 woodblock and metalcut prints on handmade Kozo paper, mounted on Somerset paper
56.5 × 38.1 (sheet size)

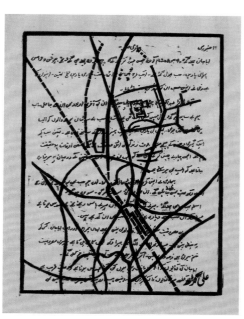

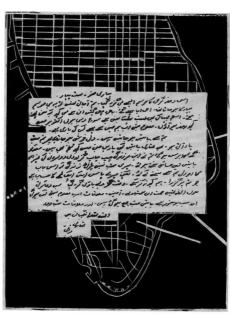

MARIA LASSNIG
(1919–2014)

In *Du oder Ich* (*You or Me*) a flushed woman stares out of the canvas, slumped as if on a chair. Her blue-green eyes are wide open, she's naked and there's a gun to her head. She also points one at us. A yellow glow emanates from her body but doesn't offer comfort. We have no idea where she is or what she is doing. Her hairless body is caught in an action and her face registers the speed of it, the shock of it.

Maria Lassnig paints from her gut. Her style is almost performance. She coined the phrase 'Körperbewusstseinsmalerei' (body-awareness painting) to explain her point of departure. For seventy years she painted the sensations of being alive, refusing to work from photographs: 'I need the real body, real air. When I paint I want everything to be as direct as possible,' she says.[65]

Success came late to Lassnig. It took seventy years before the world caught up with her and retrospectives and prizes came her way. She died aged 94 in 2014, the recipient of the Golden Lion Award for Lifetime Achievement at the Venice Biennale and an inspirational figure for a new generation of painters.

Du oder Ich (*You or Me*) 2005
Oil paint on canvas
203 × 155

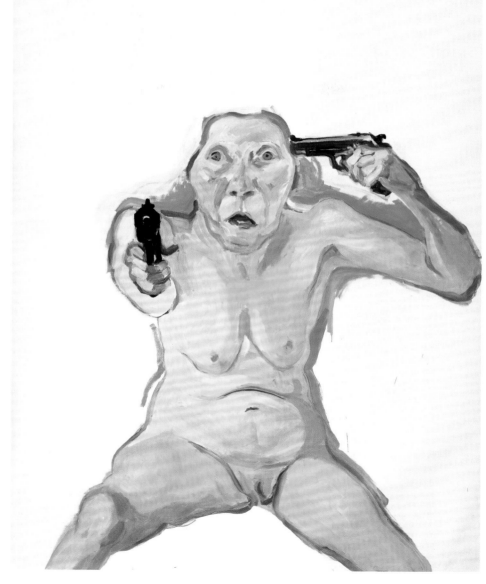

ANN-SOFI SIDÉN
(b. 1962)

In 2007 Ann-Sofi Sidén completed her six-channel video installation
In Passing. On one screen a baby lies crying on a changing mat,
attended by nurses. Meanwhile, on another screen, the baby's
mother walks the streets of Berlin, tears streaking her face. She
has just placed her child in the *Babyklappe*, or baby hatch, a facility
in Germany where babies may be abandoned in safety for others
to look after and raise. 'In 2004 I first saw a *Babyklappe* in Berlin,'
Sidén says. 'I was pregnant. I wondered how I could treat the subject
in a video installation … In 2007 I started to film the story: a young
woman after she has put the baby in the *Babyklappe*, early in the
morning in Berlin. I tried to find places where a young woman in
this situation – maybe born in this neighbourhood and where she
had given birth – would retrace her steps.'[66]

The narratives of the mother's and new-born child's journeys
unfold across six screens. The viewer has to choose which journey
they are going to follow. The choice is a difficult one, echoing the
mother's heartbreaking decision to split the family unit.

In Passing 2007
Six-channel synchronised video installation; 2 monitors, 4 video projections,
with sound
14 minutes

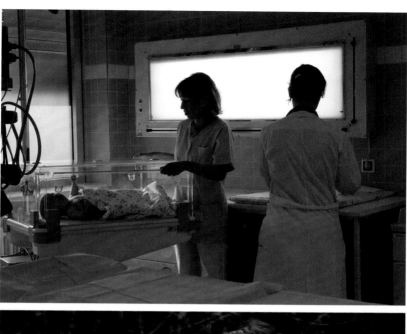

BILLIE ZANGEWA
(b. 1973)

Growing up in Botswana, Billie Zangewa started making art out of fabric. With no access to art equipment she used whatever was to hand. Now based in Johannesburg and London her silk collages are still hand-sewn and her art continues to reflect her own experiences as a Black woman.

The Rebirth of the Black Venus shows a giant, naked Zangewa striding between high-rise offices against a tangerine sky. A banner is wrapped around her body: 'surrender whole-heartedly to your complexity'. Zangewa reclaims the female nude from art history and repositions her as an active Black woman who has swapped the foam of Botticelli's seashore for the patriarchal towers of Jo'burg.

Zangewa acknowledges that women face oppression in their daily lives based on race, class and gender. 'I'm also exploring the different roles that women play in society, including motherhood and the impact that it has individually and collectively,' she says.[67] Initially her work was criticised for being too feminine, too decorative, but she stuck with it and is now enjoying success. 'I found that telling the story of my intimate life was a kind of personal empowerment,' she says, 'taking charge of my own story and using my voice.'[68]

The Rebirth of the Black Venus 2010
Silk tapestry
127 × 103

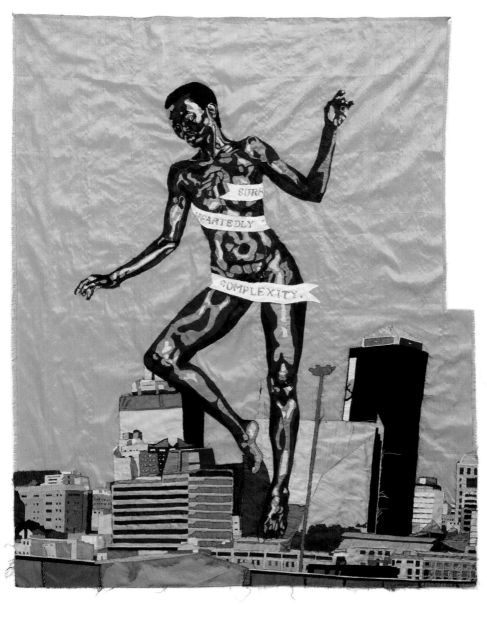

MICKALENE THOMAS
(b. 1971)

Le déjeuner sur l'herbe: Les Trois Femmes Noires is massive – over seven metres long and three metres high. It is a statement of visibility; its content a powerful reimagining of Manet's controversial masterpiece.

Before beginning a painting Mickalene Thomas photographs her own models in a corner of her New York studio styled to look like a 1970s wood-panelled sitting room. Elements of the panelling can be seen in the mosaic of patterns that surround the women in *Le déjeuner sur l'herbe: Les Trois Femmes Noires*. The three Black women sit dressed for a night out, hair coiffed and eyeshadow glittering. They look good and they know it – these women are in control of their bodies, and while they acknowledge your gaze they return it with double the intensity.

Thomas is well versed in art history and often riffs on historic paintings, choosing to rework examples of nude women painted by men for a largely male audience. Goya's *Naked Maja* 1795–1800 and Ingres's *La Grande Odalisque* 1814 become proud Black women, their bodies glistening with rhinestones, their gaze locked on your own. 'By portraying real women with their own unique history, beauty and background, I'm working to diversify the representations of black women in art,' she says.' [69]

Le déjeuner sur l'herbe: Les Trois Femmes Noires 2010
Rhinestones, acrylic and enamel on wood panel
304.8 × 731.5

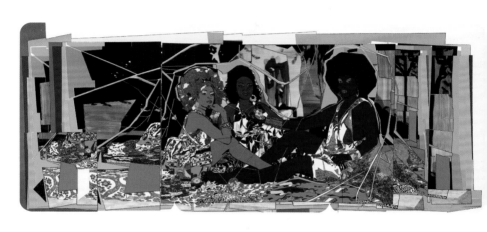

AMALIA ULMAN
(b.1989)

For five months in 2014 the young Argentinian artist Amalia Ulman reinvented herself on Instagram @amaliaulman, crafting a scripted 'live' performance called *Excellences and Perfections* that blurred the boundaries between fact and fiction. Her own friends questioned her posts, strangers sent her lewd proposals while others bonded over the stories she told through shared pictures, captions and emojis. She styled herself as a young woman in Los Angeles who wanted to 'improve' herself. She posted aspirational quotes, holiday snaps, selfies in lingerie, photos of an operation for breast enlargement (she faked it), a break-up, pictures of rose petals, make-up brushes, a gun. She changed from blonde to brunette – 'cuz im sick of ppl thinkin im dumb cos of blond hair' – and engaged in daily conversations with her 89,000 followers.[70]

Using the conventions of Instagram she produced exaggerated posts that became credible in the context of her online life. By the end her 'fiction' had become many people's 'truth'. 'People got so mad at me for using fiction,' she says. 'With *Excellences and Perfections*, that was the main critique: "It wasn't the truth? How dare you! You lied to people!" Well, that's because you should learn that everyone is lying online. I'm not the first one!'[71]

Excellences and Perfections (Instagram update, 5 September 2014) 2015
Five-month performance on Instagram, 15 April – 14 September 2014

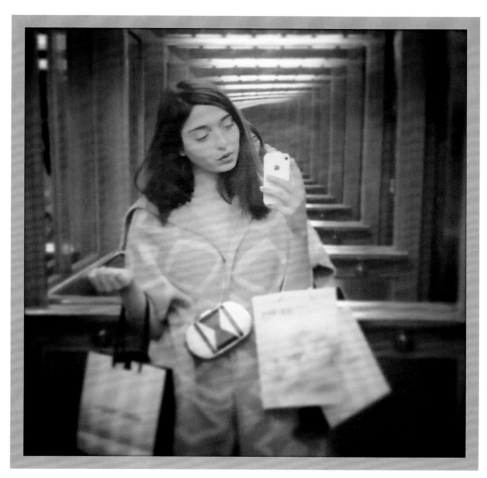

ANTHEA HAMILTON
(b.1978)

There's something unsettling about Anthea Hamilton's *Leg Chair (Cigarettes).* Black Perspex legs are hinged together around a central plinth and balance impossibly on the tips of their toes. Two oversized cigarettes form the central pillar between the spread legs. *Leg Chair (Cigarettes)* is part of a series of ten sculptures by Hamilton that are all based on cut-outs of her own legs, a recurring motif in her work. She has made chairs featuring John Travolta and Merchant Ivory's *A Room with a View* 1985, and included materials such as dried seaweed, rice cakes, records or postcards.

Hamilton works in sculpture, installation and performance, often drawn to aspects of the body to question what we think we are looking at. She wants us, the viewer, to feel her art, to have a physical response, whether this is walking around a pair of giant buttocks at her Turner Prize exhibition or witnessing a person dressed as a vegetable perform *The Squash* (both 2016). Her *Leg Chair* series seems to be a fitting twenty-first century riposte to Allen Jones's derogatory use of women's bodies in his sculptures (for example *Chair* 1969) and offers a humorous splicing of sexuality, consumerism and contemporary desire.

Leg Chair (Cigarettes) 2014
Acrylic, brass, plaster and wax
85.3 × 90.3

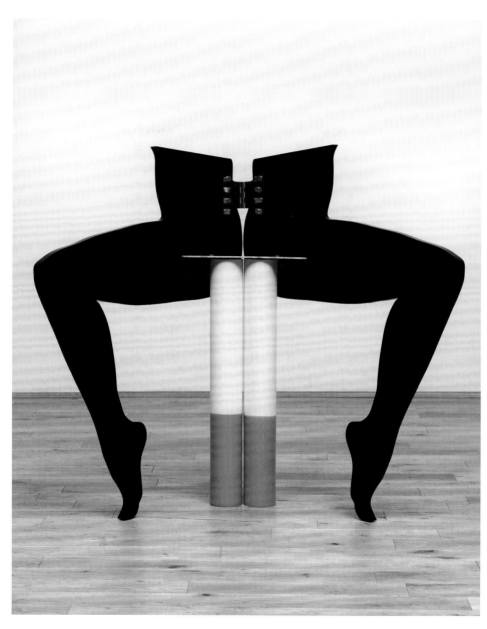

PAULINA OLOWSKA
(b. 1976)

The Alchemist is a mycologist's dream. Mushrooms push up from the floor and sprout on the sideboard. Framed illustrations of specimens line the wall behind the lady's head. (It's hard to overlook their phallic attributes but the frills and recesses also speak of female sexuality.) The woman folds her book and looks at you enquiringly. There's old-school allure in her pose and a hefty dose of ennui in her eyes.

Paulina Olowska often focusses on forgotten or overlooked female figures in history. In *The Alchemist* she uses the secret photographs of Italian architect Carlo Mollino as her starting point. His erotic Polaroids were only discovered after his death in 1973 and feature nearly-nude women posing in his private apartment. Olowska adds a dress to cover the woman's original lingerie and clusters the painting with objects to divert the gaze, giving the woman back some control.

There's often a nostalgic gleam to Oloswka's paintings as she samples images from old knitting patterns or modernist magazines and reappraises their content. She scrutinises the West's consumer capitalism and its associated objectification of women. Her paintings fit within a broad practice that includes sculpture and performance as well as magazines, talks and exhibitions.

The Alchemist 2015
Oil paint, aerosol paint and graphite on canvas
220 × 150

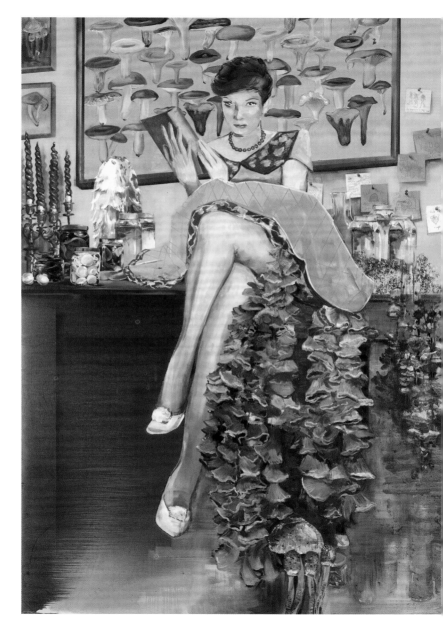

CHARLOTTE PRODGER
(b. 1974)

In a darkened room a film begins with a pair of feet balanced on a sofa. They belong to Charlotte Prodger and the framing of them moves gently up and down with her breathing as she films them on her iPhone. From this angle it is as if we are inside her, our gaze directed by her eyes and her breathing. 'The systems of the body are enmeshed with the camera,' she says. 'It's a kind of symbiosis but also a kind of grappling. I like that.'[72]

Prodger's thirty-two minute film *BRIDGIT* was shot entirely on iPhone and won her the Turner Prize in 2018. Footage moves between her flat in Glasgow, the windswept Scottish seas and foggy forests of the Highlands. The film is named after a Neolithic deity whose identity oscillated over time and place, a leitmotif for Prodger's own exploration of life as a gay woman.

BRIDGIT is a deeply personal film that explores Prodger's own sense of self in relation to queer history. The narrative is fragmentary, offering multiple insights into Prodger's feelings. It is, she says, 'less about mapping a linear history of influence or progress but rather holding these things alongside one another'.[73]

BRIDGIT 2016
Single-channel HD video
32 minutes

Notes

INTRODUCTION

1 Chimamanda Ngozi Adichie, *We Should All Be Feminists*, London 2014, p.41.

2 Sonia Boyce in Jennifer Higgie, 'Sonia Boyce: 30 Years of Art and Activism', *Frieze*, 29 May 2018, https://frieze.com/article/sonia-boyce-30-years-art-and-activism, accessed 12.12.18.

3 Lisa Tickner cited in Jo Anna Isaak, *Feminism & Contemporary Art: The Revolutionary Power of Women's Laughter*, London 1996, p.3.

4 bell hooks, *Feminism is for Everybody: Passionate Politics*, London 2000, p.viii; Lucy R. Lippard, 'Sweeping Exchanges: The Contribution of Feminism to the Art of the 1970s', *Art Journal*, vol.40, no.1–2, Fall–Winter 1980, pp.362–5 (p.362).

5 Grayson Perry, *The Descent of Man*, London 2016, p.15.

6 Mary Beard, *Women and Power: A Manifesto*, London 2017, pp.x–xi; Rebecca Solnit, *Men Explain Things to Me*, London 2014, p.4.

7 Judy Chicago in Sarah Cascone, 'Judy Chicago and Miriam Schapiro's Epoch-Making Feminist Installation "Womanhouse" Gets a Tribute in Washington, DC', Artnet.com, 13 March 2018, https://news.artnet.com/exhibitions/women-house-judy-chicago-national-museum-women-arts-1234649, accessed 21.11.18.

8 Laurie Simmons in Sheila Heti, 'Laurie Simmons', *Interview*, 4 March 2014, https://www.interviewmagazine.com/art/laurie-simmons, accessed 07.02.19.

9 Rozsika Parker and Griselda Pollock, *Old Mistresses: Women, Art and Ideology*, London 1981, p.3.

10 Lubaina Himid discussing *Framing Feminism* with Griselda Pollock, Institute of Contemporary Arts Talk, London, 21 January 1988, https://sounds.bl.uk/Arts-literature-and-performance/ICA-talks/024M-C0095X0330XX-0100V0, accessed 07.02.19. June Sarpong states that this still remains an issue: 'When it comes to representation in the media, the fight for gender equality often crosses over into, and sometimes clashes with, the fight for racial equality, and black women are at the epicentre of these two struggles.' *The Power of Women*, London 2018, p.13.

11 Lubaina Himid, *The Thin Black Line*, exh. cat., Institute of Contemporary Arts, London 1985, unpag.

12 Adrian Piper, 'The Triple Negation of Colored Women Artists', 1990 in *Feminism Art Theory: An Anthology 1968–2014*, ed. Hilary Robinson, Chichester 2015, pp.444–55 (p.453).

13 Poster reproduced in Nicola McCartney, *Death of the Artist: Art World Dissidents and Their Alternative Identities*, London 2018, p.121.

14 Linda Nochlin, 'Why Have There Been No Great Women Artists?', *Art News*, January 1971, pp.22–39 (p.37).

15 Shirin Neshat, 'Art in Exile', 2010, talk at the TEDWomen conference, Washington, DC, December 2010, https://www.ted.com/talks/shirin_neshat_art_in_exile?language=en, accessed 09.09.18.

16 Ibid.

17 Zanele Muholi, 'Ngiyopha: A Photo-biographical Project', 2009, in *Feminism Art Theory*, ed. Hilary Robinson, Chichester 2015, pp.410–14 (p.411).

18 Examples include *WACK! Art and the Feminist Revolution*, Museum of Contemporary Art, Los Angeles; *Global Feminisms*, Brooklyn Museum, New York and the opening of the Elizabeth A. Sackler Center for Feminist Art; *Kiss Kiss Bang Bang: 45 Years of Art and Feminism*, Bilbao Fine Arts Museum, Bilbao. See Viv Groskop, 'All hail the feminaissance', *Guardian*, 11 May 2007.

19 *Womanhouse*, La Monnaie de Paris, Paris, 2017 and National Museum of Women in the Arts, Washington DC, 2018; *Joan Jonas*, Tate Modern, London 2018; *Alexis Hunter*, Goldsmiths Centre for Contemporary Art, London 2018–19.

20 'Say Her Name' was launched in May 2015 as part of #BlackLivesMatter. It analysed Black women's experiences of police violence in America and argued for their perspective to be heard. See Marcia Chatelain and Kaavya Asoka, 'Women and Black Lives Matter: an interview with Maria Chatelain', *Dissent* magazine, summer 2015, https://dissentmagazine.org/article/women-black-lives-matter-interview-Marcia-Chatelain, accessed 11.02.19.

21 Erik McGregor photograph (Pacific Press/Barcroft) accompanying Sabrina Siddiqui and Sarah Betancourt, 'Police questioned Kavanaugh after Yale bar brawl in 1985', *Guardian*, 3 October 2018, p.28.

22 Jennifer Higgie, 'Sonia Boyce: 30 Years of Art and Activism', *Frieze*, 29 May 2018. See note 2.

23 See, for example, Jan Dalley, 'You've been framed', front page and p.2 of 'Life & Arts' section, *Financial Times*, 13–14 October 2018.

24 Natalie Haynes, 'It's no joke to be edited out of a panel show. I should know', *Guardian*, 12 September 2018, 'Opinion' section, p.4, https://www.theguardian.com/commentisfree/2018/sep/11/tv-editors-panel-shows-sandi-toksvig-tv-comedy-women-natalie-haynes, accessed 08.02.19; Oliver Wainwright, 'The Invisible Women', *Guardian*, 17 October 2018, pp.10–11, published online on 16 October 2018: https://www.theguardian.com/artanddesign/2018/oct/16/the-scandal-of-architecture-invisible-women-denise-scott-brown.

25 Adichie, *We Should All Be Feminists*, 2014, p.46. See note 1.

WORKS

26 Monica Sjöö, 'Art is a Revolutionary Act', from *Womenspirit* (Fall equinox, 1980), pp.55–8, reprinted in *Feminism Art Theory*, ed. Hilary Robinson, 2nd edn, Chichester 2017, pp.52–4 (p.53).

27 Sjöö, ibid., p.54.

28 VALIE EXPORT, 'Aspects of Feminist Actionism', from *New German Critique*, no.47, 1989, pp.69–92, reprinted in *Feminism Art Theory*, ed. Hilary Robinson, 2nd edn, Chichester 2017, pp.345–58 (p.347).

29 Eleanor Antin in Lisa Tickner, 'The Body Politic: Female Sexuality and Women Artists Since 1970', *Art History*, June 1978, vol.1, no.2, pp.236–49 (p.244).

30 Joan Jonas, video interview by Museum of Modern Art, New York, published 13 January 2010, https://www.youtube.com/watch?v=BGDAZU32Kbo, accessed 20.11.18.

31 Joan Jonas in *Joan Jonas*, exhibition guide, Tate Modern, London 2018, n.p.

32 Miriam Shapiro, 'The Education of Women as Artists: Project Womanhouse', *Art Journal*, vol.31, no.3, 1972, pp.268–70, reprinted (abridged) in *Feminism–Art–Theory* 2017, pp.106–7 (p.107).

33 *Ana Mendieta*, exh. cat., Centro Galego de Arte Contemporánea, Santiago de Compostela 1996, p.127.

34 Margaret Harrison, 'Tate Shots', 30 January 2014, https://www.tate.org.uk/art/artists/margaret-harrison-1248/margaret-harrison-studio-visit

35 Mary Kelly, 'Preface', in *Post-Partum Document*, London in *Feminism Art Theory*, ed. Hilary Robinson, 2nd edn, Chichester 2015, pp.310–14 (p.312).

36 Judy Chicago, *Women Art and Society: A Tribute to Virginia Woolf*, The Black-E, Liverpool in partnership with Through The Flower, Belen, New Mexico, 2012, p.18.

37 Ibid., p.18.

38 Text from Schneemann's 1973 film *Kitch's Last Meal* included on the print *Interior Scroll* 1975.

39 Martha Rosler in 'In Conversation with Martha Rosler', *Another Gaze: A Feminist Film Journal*, film interview, published 23 February 2016, https://www.anothergaze.com/in-conversation-with-martha-rosler/, accessed 06.02.19.

40 Sanja Iveković, interviewed for ZKM Museum of Contemporary Art, Karlsruhe, Germany, published 16 March 2012, https://www.youtube.com/watch?v=fPq6WAI9u8U, accessed 12.12.18.

41 Paul Clinton interview with Cosey Fanni Tutti, 'Time to Tell', *Frieze*, 12 April 2017 https://frieze.com/article/time-tell, accessed 03.01.19.

42 Rose Finn-Kelcey in Eleanor Roberts, 'The Feminist Performances of Rose Finn-Kelcey', *Oxford Art Journal*, vol.38, no.3, 2015, pp.387–403 (p.397).

43 Rose Finn-Kelcey, ed., *Rose Finn-Kelcey*, London 2013, p.14.

44 Alexis Hunter, artist statement, https://www.brooklynmuseum.org/eascfa/feminist_art_base/alexis-hunter, accessed 16.01.19.

45 Lynn Hershman Leeson, lecture at Museum of Modern Art, New York, 1994, text at http://www.lynnhershman.com/wp-content/uploads/2016/06/Talk-at-MOMA-NY.pdf, accessed 17.01.19.

46 Cindy Sherman in Monique Beudert and Sean Rainbird, *Contemporary Art: The Janet Wolfson de Botton Gift*, exh. cat., Tate Gallery, London 1998, p.99.

47 Barbara Kruger in Kate Linker, *Love for Sale: The Words and Pictures of Barbara Kruger*, New York 1990, p.62.

48 Lubaina Himid, 'Tate Shots',

published 22 October 2018, https://www.youtube.com/watch?v=Nc1i66JYaJE, accessed 20.01.19.

49 Suzanne Lacy discussing *The Crystal Quilt*, Tate audio, https://www.tate.org.uk/context-comment/audio/crystal-quilt-suzanne-lacy-crystal, published 17 June 2016, accessed 17.01.19.

50 Adrian Piper in Rozsika Parker and Griselda Pollock, *Framing Feminism: Art and the Women's Movement 1970–1985*, London 1987, p.270.

51 Helen Chadwick quoted in Marina Warner, 'In the Garden of Delights: Helen Chadwick's *Of Mutability*' in *Of Mutability*, exh. cat., Institute of Contemporary Arts, London 1986, n.p.

52 Lee Bul in Cal Revely-Calder, 'The monstrous bodies of Lee Bul', *Apollo*, 10 July 2018, https://www.apollo-magazine.com/the-monstrous-bodies-of-lee-bul/, accessed 17.01.19.

53 Mona Hatoum quoted in Michael Archer, Guy Brett and Catherine de Zegher, *Mona Hatoum*, London 1997, p.140.

54 Xiao Lu interviewed by Monica Merlin, Tate, London, published 21 February 2018, https://www.tate.org.uk/research/research-centres/tate-research-centre-asia/women-artists-contemporary-china/xiao-lu, accessed 18.01.19.

55 Louise Bourgeois quoted in Rainer Crone and Petrus Graf Schaesberg, *Louise Bourgeois: The Secret of the Cells*, Munich 1998, p.81.

56 Jenny Saville, interviewed by Hunter Davies, *Independent*, 1 March 1994, in Charlotte Mullins, 'The Skin of the Day', *All Too Human*, exh. cat., Tate Britain, London 2018, pp.54–65 (p.62).

57 Shirin Neshat talk at TEDWomen conference, Washington, DC, December 2010. https://www.ted.

com/talks/shirin_neshat_art_in_
exile?language=en, accessed
12.12.18.

58 Stephanie Convery interviews
Tracey Moffatt, *Guardian*, 23 March
2017, https://www.theguardian.com/
artanddesign/2017/mar/24/
tracey-moffatt-if-it-becomes-a-little-
terrifying-then-im-interested,
accessed 24.01.19.

59 Carrie Mae Weems discussing
*From Here I Saw What Happened and
I Cried*, 7 September 2017, audio,
Tate/Khan Academy, https://www.
tate.org.uk/context-comment/audio/
carrie-mae-weems-here-i-saw,
accessed 24.01.19.

60 Matthew Collings, *Sarah Lucas*,
London 2002, p.72.

61 Paula Rego, *Web of Stories: Life
Stories of Remarkable People*,
published 18 September 2017,
https://www.youtube.com/watch?v=
igrv3gpT6qU, accessed 25.01.19.

62 Sonia Boyce, exhibition guide,
Manchester Art Gallery, 2018,
http://manchesterartgallery.org/
exhibitions-and-events/exhibition/
sonia-boyce/, accessed 25.01.19.

63 Zanele Muholi, interview by Gabi
Ngcobo, *Artthrob*, no.112, December
2006, http://www.artthrob.co.
za/06dec/artbio.html, accessed
28.01.19.

64 Zarina Hashmi, '54th Venice
Biennale: Zarina Hashmi (India)', *ART
iT*, June 2011, http://www.art-it.asia/u/
admin_ed_feature_e/
FHt6zkTwqhKfNOJcUbuV/, accessed
28.01.19.

65 Maria Lassnig in Kathryn Hughes,
'Maria Lassnig: Under the Skin',
Guardian, 14 May 2016, https://www.
theguardian.com/artanddesign/
2016/may/14/maria-lassnig-under-
the-skin, accessed 28.01.19.

66 Ann-Sofi Sidén on 'Orientierung',
ORF TV, 21 November 2010, https://
www.youtube.com/watch?v=
m1H1ooEOBT8, accessed 28.01.19.

67 Bille Zangewa in conversation
with Rosalind Duguid, 'Billie Zangewa
on her Sociopolitical Silk Works',
Elephant, 18 June 2018, https://
elephant.art/billie-zangewa-
discusses-her-socio-political-silks/,
accessed 28.01.19.

68 'Billie Zangewa is Proving Critics
Who Say Feminine Art Doesn't Sell
Wrong', *Sunday Times*, 8 July 2018,
https://www.timeslive.co.za/
sunday-times/lifestyle/2018-07-07-
billie-zangewa-is-proving-critics-
who-say-feminine-art-doesnt-sell-
wrong/, accessed 28.01.19.

69 Tiffany Y. Ates, 'How Mickalene
Thomas is Ushering in a New Wave
of Contemporary Art', *Smithsonian
Magazine*, January 2018, https://
www.smithsonianmag.com/
arts-culture/mickalene-thomas-
ushering-new-wave-contemporary-
art-180967496 /#C7TTCI0g9S
JJ7tC3.99, accessed 29.01.19.

70 See posts from Ulman's
performance at http://webenact.
rhizome.org/excellences-and-
perfections, accessed 29.01.19.

71 Amalia Ulman in Rachel Small,
'Amalia Ulman', *Interview*, published
14 October 2015, https://www.
interviewmagazine.com/art/
amalia-ulman, accessed 08.02.19.

72 Charlotte Prodger, 'Tate Shots',
published 17 September 2018,
https://www.youtube.com/watch?v=
AsVWk5DIbCE&vl=en-GB, accessed
29.01.19.

73 Ibid.

Acknowledgements

Many thanks to all the artists
included, and to the women
who helped shape this book:
Zuleyha Bektas, Elena Crippa,
Susie Hamilton, Karin Hanssen,
Lulu Hedges, Sarah Krebietke,
Emma O'Neill, Emma Poulter,
Valentina Ravaglia. Writing is both
a solitary pursuit and a team effort
so thank you also to my family
for their continued support and
understanding. A final thank
you to Virginia Woolf for blazing
the way for women writers to
demand a room of their own.

Further reading

Chimamanda Ngozi Adichie, *We Should All be Feminists*, London 2014

Mary Beard, *Women and Power: A Manifesto*, London 2017

Simone de Beauvoir, *The Second Sex* (1949), transl. Constance Borde and Sheila Malovany-Chevallier, London 2015

John Berger, *Ways of Seeing*, London 1972

Michael Bird, *Studio Voices: Art and Life in 20th-Century Britain*, London 2018

Norma Broude and Mary Garrard, eds., *The Power of Feminist Art: Emergence, Impact and Triumph of the American Feminist Art Movement*, New York 1994

Deborah Cameron, *Feminism*, London 2018

Whitney Chadwick, *Women, Art and Society*, London 2007

Judy Chicago and Miriam Shapiro, *Womanhouse*, exh. cat., 1972, Reprint (29pp.) available from www.throughtheflower.org

Mary Eagleton, ed., *A Concise Companion to Feminist Theory*, Malden 2003

Germaine Greer, *The Female Eunuch* (1970), London 1993

Siri Hustvedt, *A Woman Looking at Men Looking at Women: Essays on Art, Sex, and the Mind*, London 2016

Jo Anna Isaak, *Feminism & Contemporary Art: The Revolutionary Power of Women's Laughter*, London 1996

Stanlie M. James and Abena P. A. Busia, eds., *Theorizing Black Feminisms: The Visionary Pragmatism of Black Women*, London 1993

Kiss Kiss Bang Bang: 45 Years of Art and Feminism, exh. cat., Museo de Bellas Artes de Bilbao, Bilbao 2007

Lucy R. Lippard, 'Sweeping Exchanges: The Contribution of Feminism to the Art of the 1970s', *Art Journal*, vol.40, no.1–2, Fall–Winter 1980, pp.362–5

Lisa Gabrielle Mark, ed., *WACK! Art and the Feminist Revolution*, exh. cat., Museum of Contemporary Art, Los Angeles 2007

Nicola McCartney, *Death of the Artist: Art World Dissidents and Their Alternative Identities*, London 2018

Charlotte Mullins, 'The Skin of the Day', in *All Too Human*, exh. cat., Tate Britain, London 2018, pp.54–65

Laura Mulvey, 'Visual Pleasure and Narrative Cinema' (1975) in *Contemporary Film Theory*, ed. by Anthony Easthope, Harlow 1993, pp.111–24

Lynda Nead, *Art, Obscenity and Sexuality*, London 1992

Linda Nochlin, 'Why Have There Been No Great Women Artists?', *Art News*, January 1971, pp.22–39

Craig Owens, *Beyond Recognition: Representation, Power and Culture*, University of California Press, Los Angeles 1994

Rozsika Parker and Griselda Pollock, *Old Mistresses: Women, Art and Ideology*, London 1981

Rozsika Parker and Griselda Pollock, *Framing Feminism: Art and the Women's Movement 1970–1985*, London 1987

Grayson Perry, *The Descent of Man*, London 2016

Alex Pilcher, *A Queer Little History of Art*, London 2017

Griselda Pollock, *Vision & Difference: Femininity, Feminism and the Histories of Art*, London 1988

Griselda Pollock, *Differencing the Canon: Feminist Desire and the Writing of Art's Histories*, London 1999

Helena Reckitt, ed., *Art and Feminism*, London 2012

Helena Reckitt, ed., *The Art of Feminism: Images That Shaped the Fight for Equality*, London 2019

Alan Rice, *Radical Narratives of the Black Atlantic*, London 2003

Hilary Robinson, ed., *Feminism Art Theory: An Anthology 1968–2014*, Chichester 2015

June Sarpong, *The Power of Women: Why Feminism Works for Everyone*, London 2018

Rebecca Solnit, *Men Explain Things to Me*, London 2014

Elizabeth Weed, Naomi Schor, eds., *Feminism Meets Queer Theory*, Bloomington, IN 1997

Mirjam Westen, ed., *Rebelle: Art and Feminism 1969–2009*, Arnhem 2009

Virginia Woolf, *A Room of One's Own and Three Guineas* (1929, 1938), Oxford 2008

Index

Note: page references in italics indicate images of artworks; 'n' indicates notes.

Credits